Painting Landscapes & Nature

RICHARD BOLTON

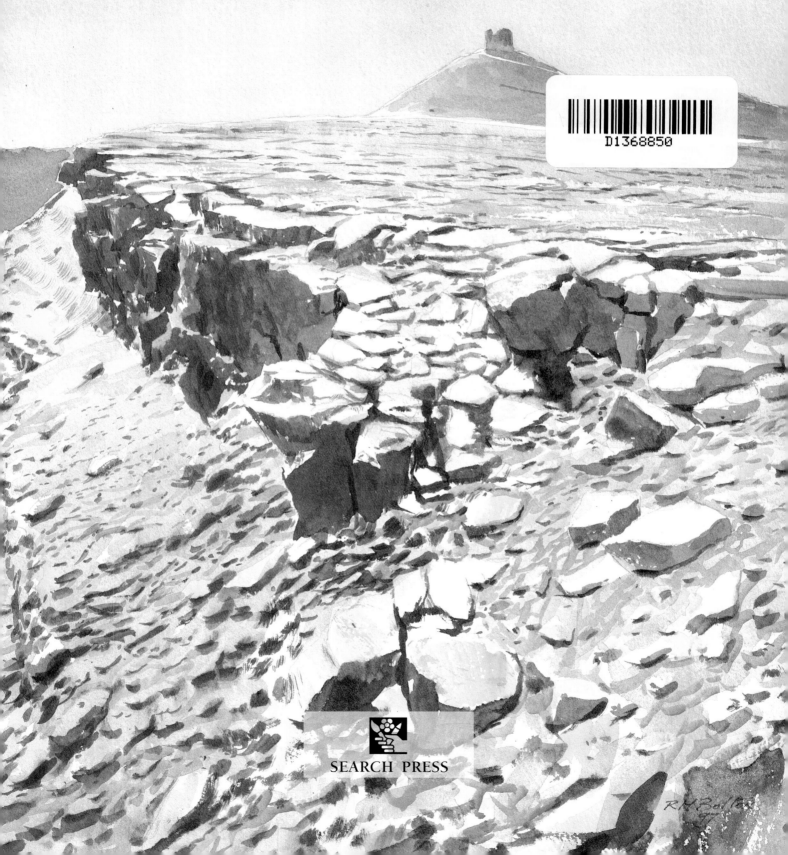

SEARCH PRESS

First published in Great Britain 2002

Search Press Limited
Wellwood, North Farm Road,
Tunbridge Wells, Kent TN2 3DR

Reprinted 2005 (twice), 2006

Text copyright © Richard Bolton 2002

Photographs by Charlotte de la Bédoyère, Search Press
Studios

Photographs and design copyright © Search Press Ltd. 2002

ISBN 0 85532 989 0

The Publishers and author can accept no responsibility for any
consequences arising from the information, advice or
instructions given in this publication.

Suppliers
If you have difficulty in obtaining any of the materials and
equipment mentioned in this book, please visit the Search
Press website for details of suppliers: www.searchpress.com

Alternatively, you can write to the Publishers at the address
above, for a current list of stockists, including firms which
operate a mail-order service; or you can write to Winsor &
Newton, requesting a list of distributers.

Winsor & Newton, UK Marketing
Whitefriars Avenue, Harrow,
Middlesex, HA3 5RH

Publishers' note

All the step-by-step photographs in this book feature the
author, Richard Bolton, demonstrating how to paint
landscapes and nature in watercolour. No models have
been used.

There are references to sable and other animal hair brushes
in this book. It is the publishers' custom to recommend
synthetic materials as substitutes for animal products
wherever possible. There is now a large range of brushes
available made from artificial fibres, and they are
satisfactory substitutes for those made from natural fibres.

With thanks to Roz Dace and Sophie Kersey at
Search Press for their help in producing this book.

Front cover
Arthur's Pass
660 x 410mm (26 x 16¼in)
This painting is also shown on pages 80–81

Page 1
Hilltop Tree
270 x 345mm (10½ x 13½in)
This tree was on top of a hill in Kaikoura, New Zealand.

Pages 2–3
Ramon Crater, Israel
525 x 330mm (20¾ x 13in)
*This is a truly spectacular setting in the desert with grand views
across a scene that has changed little with the passage of time. The
shelving rock strata create ridges and patterns that make a
fascinating subject to paint.*

Page 5
Taroko Gorge, Taiwan
340 x 530mm (13½ x 20¾in)
*This gorge is famous for the cutting of a road in a sheer cliff,
achieved by unskilled workers at great risk to their lives. It can be
seen in a cliff face in my painting. I chose this view for the
dramatic effect of sunlight through the narrow aperture between
the rock faces.*

Printed in Malaysia by Times Offset (M) Sdn Bhd

Contents

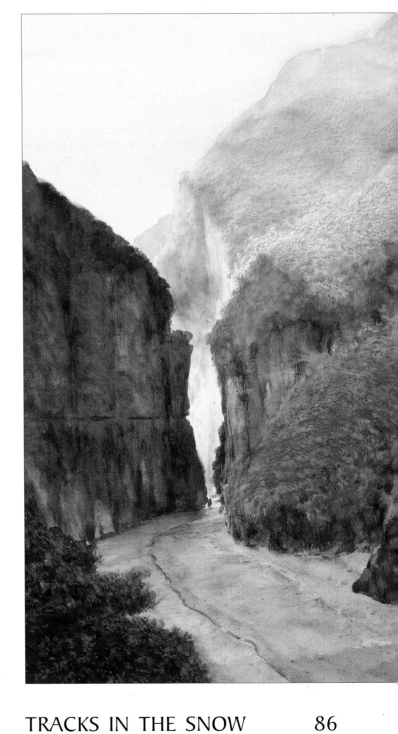

Introduction

For many painters the first introduction to watercolour comes as a gift, in the form of a compact tin containing a few tubes or pans of paint and a brush. It looks modest, but this basic kit is all that is needed to paint a masterpiece. Every master of the art has worked with a similar set. All the potential is there in the tin, so it is not surprising that for generations, watercolour has been such a popular pastime, and for many, a passion.

Watercolour is often referred to as the English art. In the nineteenth century, watercolour painting became one of those accomplishments, along with playing the piano, that every upright Victorian should learn. Queen Victoria was a good watercolour artist, and in an era before photography, servicemen in the navy were encouraged to paint, since it was a useful skill for keeping a record of coastlines and defences.

This enthusiasm took watercolour to new heights, and the achievements of some painters are truly breathtaking. Early masters of the art had to wrestle with less than perfect paper, and had to be inventive with their colour range, grinding down minerals in search of new colours. We are more fortunate: the range of colours and equipment available today gives us infinite choice.

This book concentrates on the painting of landscapes and nature, probably the most popular area of watercolour. It embraces landscapes from different parts of the world, as I take my paints with me on my travels. This is one of the great assets of watercolour: the painting equipment required to take on a journey is so small and compact that it can easily be included in one's luggage. Visiting distant lands and seeing its natural wonders first-hand is a life-enhancing experience, and to be able to transfer this experience to a painting makes it more enjoyable. I hope you find these pages an encouragement and assistance as you go on your own journey into watercolour painting.

Glacial River Bed, Tibet

340 x 240mm (13½ x 9½in)
Water reflects sunlight in this scene, simply achieved by painting out in masking fluid before applying paint. This keeps the white areas crisp and sharp-edged.

Materials

PAINTS

Watercolour paints come in tubes or pans and there is a wide choice of brands and colours to choose from. Tubes are the most accessible, as the paint is already wet, so little time is spent on loading the brush. Pans are moist and are also easy to charge a brush with. They are not to be confused with the old cakes of watercolour which required scrubbing to get any strength of colour. My paint tin is full of pans, which I refill from tubes. This method gives me the practicality of the paint set, and I can refill the pans from tubes of different brands, giving me a lot of room for experimentation. The central aisle of my paint tin is really meant to hold brushes, but I use it to contain more pans.

I only squeeze a little paint into the pans as I need it, as this way the colours stay clean, which can be a problem with full pans of paint.

Paints are often produced in two ranges, students' and artists' quality. The main difference is in the amount of pigment to vehicle, artists' quality being the strongest. The artists' range of colours is also greater. The other difference is that expensive pigments are often substituted by similar but cheaper alternatives. In this case, the tube will be marked 'Alizarin Crimson (hue)' or 'Cobalt Blue (hue)'.

Paints also have a light fastness register, which is noted on the tubes, since some colours are more fugitive than others and will fade faster. It is wise to keep all watercolours away from the sun as much as possible, and never hang a painting where it will catch direct sunlight.

My colours are loosely organised into groups, with the blues in one area and yellows in another. One pan is reserved for the opaque colours Naples yellow and Chinese white.

TIP

It can be difficult to twist the top off a tube of paint if it has become gummed up with dry paint. A pair of pliers close to hand can be very helpful.

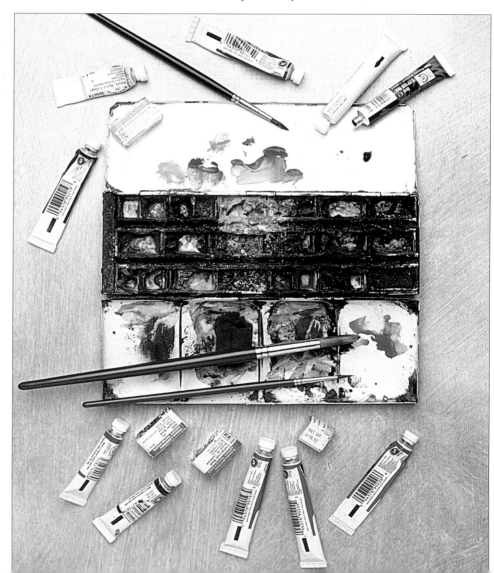

My paint tin, filled with pans, with extra tubes of paint used to refill the pans as required.

BRUSHES

There is a bewildering variety to choose from. Traditionally the Kolinsky sable was considered the finest of watercolour brushes and it still is, but the price is a serious consideration. A good compromise is a mix of sable and synthetic, though I find many of the synthetic brushes are now also very good. Their prices vary greatly, and it would be wise to go for the best in this group.

Chinese brushes are also worth considering. They look completely different to the typical western brush with its metal ferrule. They are usually a straight tube, often a length of bamboo with the hairs protruding from the end. I have had a lot of success with these brushes, but choosing the right one is quite difficult, as many different hairs are used.

Large brushes

These are needed for washes and for covering large areas such as the sky. I use a 2.5cm (1in) flat ox-hair brush and a size 14 synthetic and sable round, and I also have a large, round Chinese-style brush that can hold a lot of paint. A large round still comes to a fine point, so can be very versatile.

Middle-sized brushes

Sizes 6 to 12 provide mid-range brushes, which are good all-round brushes used for the main bulk of the painting. I use two, one for painting and the other for softening edges.

Small brushes

A size 2 or 3 should be used for very fine work such as pebbles on a beach or grass. The long-haired rigger is used for long strokes. This brush got its name because it was used by marine artists to paint in the fine lines of rigging on a sailing vessel. The rigger is useful in landscape painting for grass, twigs and many other applications where very fine lines are needed.

Tip

Larger brushes tend to be more useful than small ones, as a large round brush in good condition will still come to a fine point. Smaller brushes are often selected because of their price.

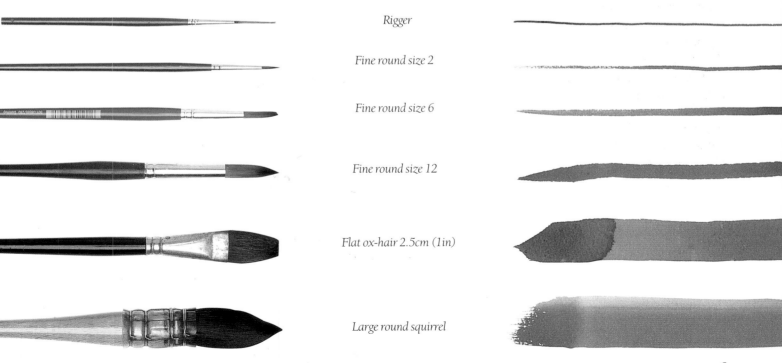

Rigger

Fine round size 2

Fine round size 6

Fine round size 12

Flat ox-hair 2.5cm (1in)

Large round squirrel

PAPER

Watercolour paper is produced from cellulose cotton or rag. Most papers we use are made from wood pulp and will brown with age, but watercolour paper will stay white indefinitely. Watercolour paper also has to be very strong to cope with the stretching process and the rough treatment it can get through some of the techniques involved in painting.

The choice of paper will greatly affect the outcome of your painting, so it is important to find a surface that suits you. Papers vary in surface texture and sizing (absorbency), and it is surprising the difference this can make. If you can obtain manufacturer's samples, this will be a great help, as you can look at them and experiment with brushstrokes, to get some idea of the character.

Paper falls into three main groups: Hot Pressed, Not and Rough. The most popular is Not, which has a lightly textured surface like cartridge paper, and can be used for all watercolour techniques. Rough, as the name suggests, has a heavily textured surface which will be extremely effective in any dragging techniques where a speckle of paint is required on the paper. Hot Pressed is smooth, so effects where paper texture is required will not work, but it has many other possibilities and is good for fine detail.

Paper comes in different thicknesses and is measured in grammes per square metre (gsm). My favourite surface is a fairly thin paper, 190gsm Saunders Not, though I use other papers too. Many artists prefer to work on a thicker paper: 300gsm, which has the advantage that you do not need to stretch it (see page 20). This has to be balanced against the extra cost. I prefer to work on the drum-tight, flat surface of stretched paper. Once you find a paper that you like, try to stick with it, as this way you will learn exactly what it is capable of and get the best use out of it.

TIP

Learning to paint with watercolours can waste paper, so turn it over and use both sides.

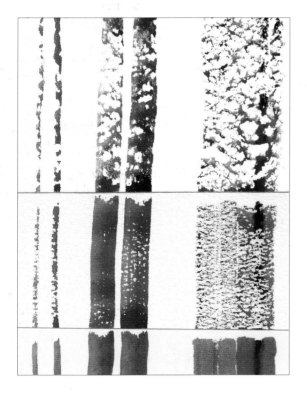

Rough, Not and Hot Pressed paper. Shown on the left are the effects produced by different brushstrokes on the three types of paper. Note the useful speckled effect created by a water-starved brush dragged across the Rough paper (top), and the more subtle speckle on Not paper (in the middle). The same brushstrokes come out as solid colour when used on smooth Hot Pressed paper (bottom).

OTHER EQUIPMENT

Painting board
These can be made from block board, plywood or MDF. If you are going to stretch your paper, make sure you have a least two boards so that you always have a stretched surface to work on. **Gummed tape** is used for attaching wet paper to the board for stretching.

Ruler
Use an **eraser** alongside a ruler if you want to rub out a straight line. A ruler can also be used with a brush for painting straight lines, but be careful to avoid paint seeping under the ruler and spoiling the work.

Hairdryer
This is used to speed up the drying process.

Palette
For mixing colours.

Masking fluid
Masking fluid is supplied in art shops as a liquid, clear or tinted. The tinted is best as it can be difficult to see where the clear fluid has been painted. It can be painted on to the paper to mask it from paint, and when the painting has dried, it can be rubbed away with an eraser or a finger, leaving behind white paper (see page 25).

Ox gall liquid
This is a wetting agent and makes the paper more receptive to watercolour. It can also be used as a dispersant, to create unusual effects (see page 25).

Pencil
Most paintings begin with some preliminary sketching. Use a soft pencil to avoid damaging the paper.

Eraser
To remove unwanted pencil lines, or to rub out painted areas in order to create highlights (see page 24).

Craft knife, penknife or razor blade
For scratching out (see page 24), or cutting out lines in a painting (see page 25). The flat edge of a razor blade can also be dragged across very dry paper to produce speckled highlights.

Sponge
For lifting off large areas of paint. A sponge can be used to create effects by dabbing (see page 25). Natural sponges are best but it is worth experimenting with small synthetic ones. A **sponge brush** can also be used.

Pliers
For twisting the tops off tubes of paint when they have become dried on.

Water container
Choose one with a large, flat base so that it can not be knocked over too easily. Mine is collapsible and was bought in China.

Paper towel or tissue
For removing excess paint, dabbing to produce highlights (see page 25) and for general cleaning up.

Candle wax
Used as a resist to create textural highlights (see page 24).

Salt
Sprinkle salt on wet paint, and as it dissolves it creates interesting patterns and textures (see page 25).

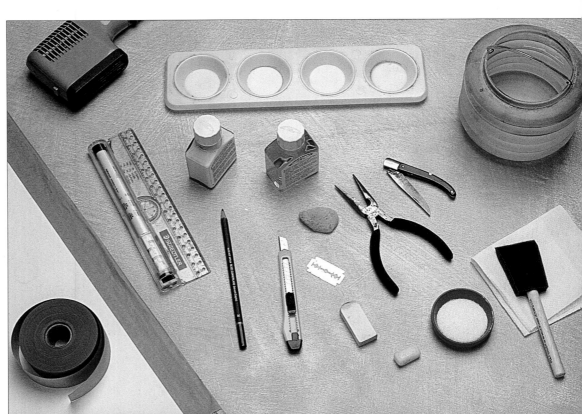

Painting outdoors

One of the benefits of watercolour painting is the minimal equipment needed to complete a painting. If you are out walking whilst on holiday or travelling, it is quite easy to take your painting equipment with you. Most paint tins are quite compact and will fit into a pocket or bag, but if you really want to travel light, there are small sets available that fold out to give you a palette and water container.

Paper can be bought in blocks, rather like a sketchbook, except that the pages are stuck down along all four edges. This will save you the job of stretching the paper and you will be able to leave your painting board at home. Really heavy papers do not need stretching, so this is another option.

Brushes need to be looked after to maintain their points, and are best carried around in a folder or plastic tube. Most painters make their own folders, either from cloth or bamboo matting. The latter is particularly good because it can be rolled up and yet gives good protection as well as allowing air to circulate.

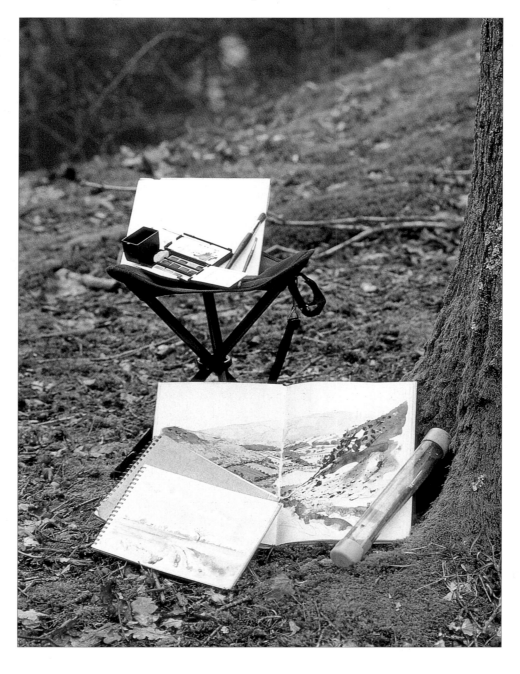

A lightweight three-legged stool; small paint tin with fold-out palette and water container; brushes, some in a protective tube; and sketchbooks.

12

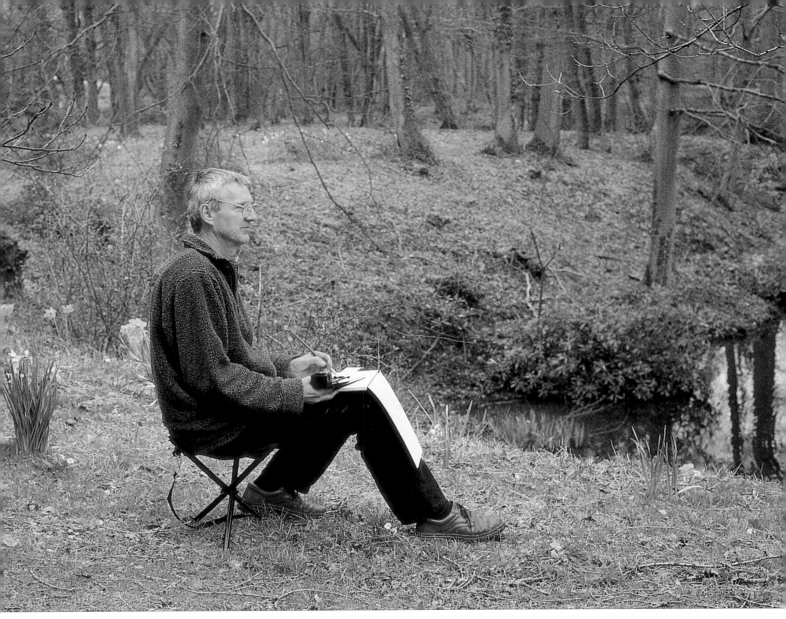

The artist at work outdoors

If you prefer to work at an easel, there is plenty of choice, from traditional wooden ones to modern camera tripod types. I prefer to sit and work with my painting on my lap. For this I carry a lightweight three-legged folding stool that I can sling over my shoulder when I am out walking. Painting equipment can fit into a small shoulder bag, and if you are using a compact set, you can even carry it in a waist bag.

Try to make yourself comfortable for painting, and if possible get out of the sun or wind. Weather conditions can be a big problem: on a warm, sunny day you might find that your paints dry too quickly, and in really hot conditions, you can find the paints drying in the palette before reaching the paper. In cool conditions on the other hand, you can wait ages for a wash to dry. Sunlight on paper can be quite dazzling, so angle yourself to avoid this as much as possible. Ideally you should have a couple of large umbrellas to shade your workspace, but unfortunately this luxury is too awkward for most of us to carry. Sunglasses can make painting in bright light much less stressful.

Colour

yellow ochre

raw sienna

cadmium yellow

Naples yellow

scarlet lake

alizarin crimson

Indian red

burnt sienna

burnt umber

intense blue

French ultramarine

turquoise

Prussian blue

cerulean blue

viridian

emerald green

sap green

Colours have their own characters and behave differently on the paper. Some colours are ground pigments and the fine particles can fall into the hollows of the paper, accentuating the texture of the paper. They can also be more easily removed from the paper by sponging or lifting out with a brush. These granular colours include raw sienna, burnt sienna, burnt umber, cobalt blue and ultramarine blue. Other colours are dyes and once on the paper leave a permanent stain: these colours include the Winsor range by Winsor & Newton, sap green and alizarin crimson.

This example shows how granular colours have been sponged away leaving behind sap green which is a dye and less easy to remove.

The chart on the left shows a fairly wide range of colours. As you experiment with them, you will develop preferences and end up with a handful of colours that you use a lot, and others that are introduced occasionally. I have a range of favourite colours which are always in my paint box. They are:

Raw sienna A strong, rich yellow. This can be used in all areas of painting, imparting a warm glow to skies or a richness to the landscape. It is ideal for foliage greens when mixed with ultramarine blue.

Naples yellow This is a strange colour, an opaque pale yellow. I find it useful in so many applications: it can be applied as a wash to give a warm tone to the paper, and it mixes with other colours to give a range of sensitive shades. As opaque gouache it is mixed with other watercolours for overpainting, the technique in which opaque colours are painted on top of transparent watercolours.

Scarlet lake Reds can be a bit disappointing: they look stunning when wet, but once they dry they seem to lose their magic. Scarlet lake is a good, bright red that stays bright after drying.

Alizarin crimson A strong, deep red that can give a warm blush to any mix.

Burnt sienna This is one of the colours I use the most. It is a rich orange brown and finds its way into most of my paintings. I add it to greens to give a good foliage colour, and I also use it for earth colours from soil to the bark of trees. It is particularly good for rust.

French ultramarine This is the blue I use the most. It is a granular pigment and can be lifted off the paper with a sponge or a damp brush. It is

a good mixer and is frequently combined with burnt sienna or burnt umber in landscape scenes.

Prussian blue A strong, dark, cold blue. I use this if I want a really dark colour. Combined with Indian red or burnt umber, it gives a colour approaching black. It has a high staining quality.

Cerulean blue A light blue that can be very useful in sky scenes. Mixed with other colours it can give subtle greys, well suited to my local scenery.

Viridian Mixed with burnt umber, Indian red or burnt sienna, viridian gives a useful range of foliage greens. A little goes a long way.

Emerald green Another good green for foliage, much lighter than viridian, which mixes well with other colours. I often use it with Naples yellow to give pale shades of green.

Winsor blue This is a new blue in my palette. When I was painting in Australia, I found the blues in my paint box were not blue enough for the Australian sky! This blue is strong and vibrant.

These examples show how colours interplay, and some of the possibilities as they blend with each other.

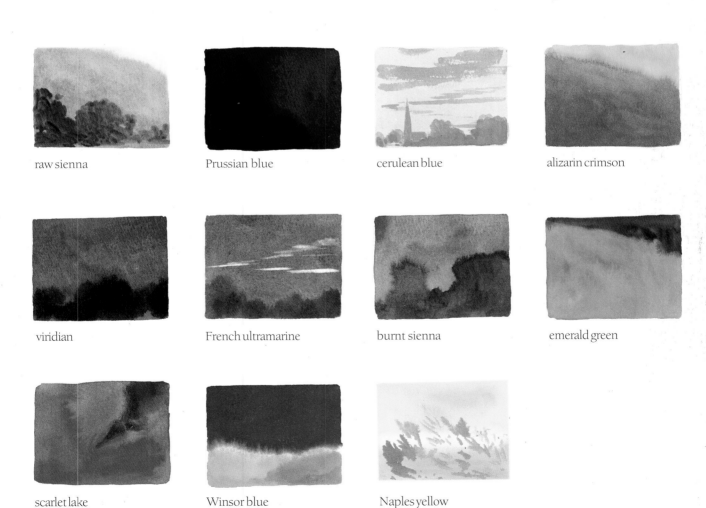

raw sienna	Prussian blue	cerulean blue	alizarin crimson
viridian	French ultramarine	burnt sienna	emerald green
scarlet lake	Winsor blue	Naples yellow	

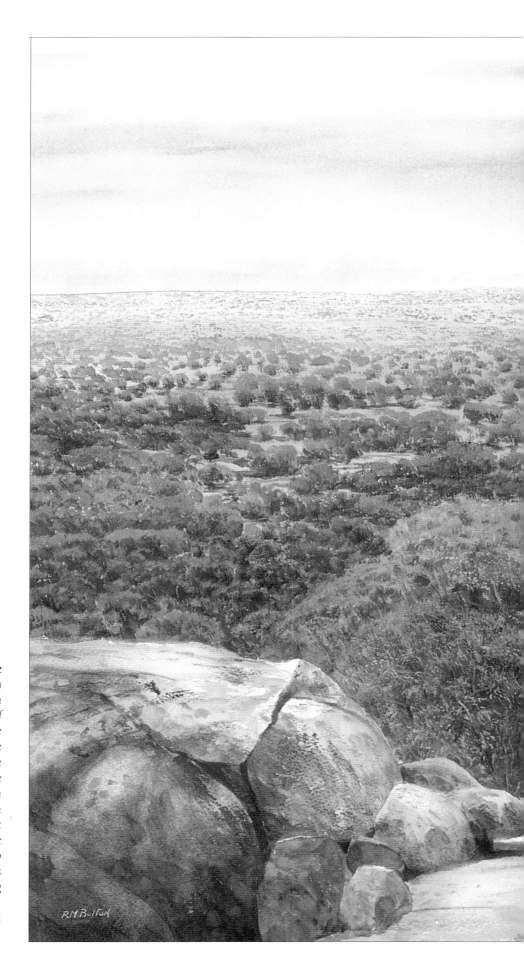

Undara Landscape

520 x 740mm (20½ x 29¼in)
The savannah grasslands in Northern Australia contrast greatly with the kind of landscape I am used to in England. The reds and yellows in this outback scene have been used strongly to capture the rugged landscape. I used raw sienna as the main yellow, as it gives a good golden colour. Other hot colours were used, such as Indian red, burnt sienna and scarlet lake. The rocky formation in the foreground required a lot of work to develop the patina of age. This was achieved by scrubbing the paint on, using the dry brush technique to give textures, and then working in the shadows with ultramarine blue and dioxazine violet.

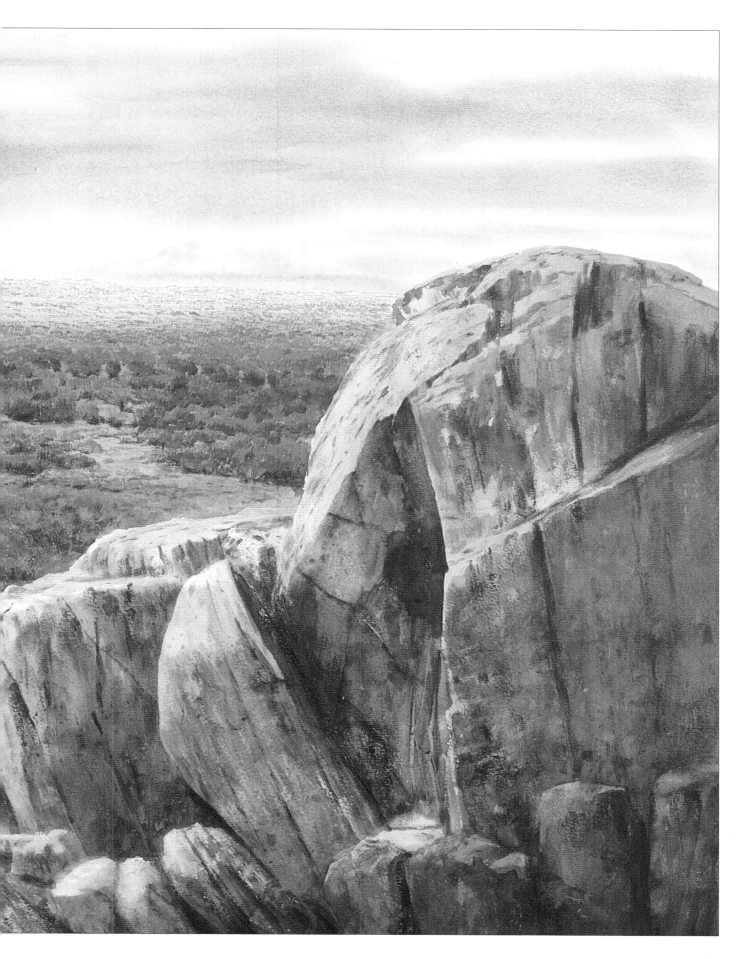

Tone

Tone is how we view a scene from light to dark. This can be confusing in a painting, because we are also working in colour. If we limit our palette to one colour, sepia, burnt umber or Payne's gray, we can work solely in tone to get a better understanding.

Before painting, look at the scene and pick out the darkest area. This is your benchmark – the darkest you can reach in your tonal range, so no other part of the painting should be painted this dark. In watercolour this is critical since, because of the transparent nature of the medium, large areas of dark colour can be difficult to handle. The lightest tone will be the white of the paper. In the scene you are painting, there may be only one of two points that reach this end of the scale – often a highlight in water or the sky itself. Masking fluid may be handy to mask these out. Between these extremes will be a range of tones to be assessed and built up in the process of painting.

This painting of the mill at St Ives has been painted in one colour, burnt sienna. Despite its limitations, it still captures the warm hues of a summer evening. The tonal range moves from the darkest area in the foreground detail to the lightest, which is the background sky and its reflection in the water. The brightness of the sky is also reflected in the windows; masking fluid was touched in here to preserve the whiteness of the paper.

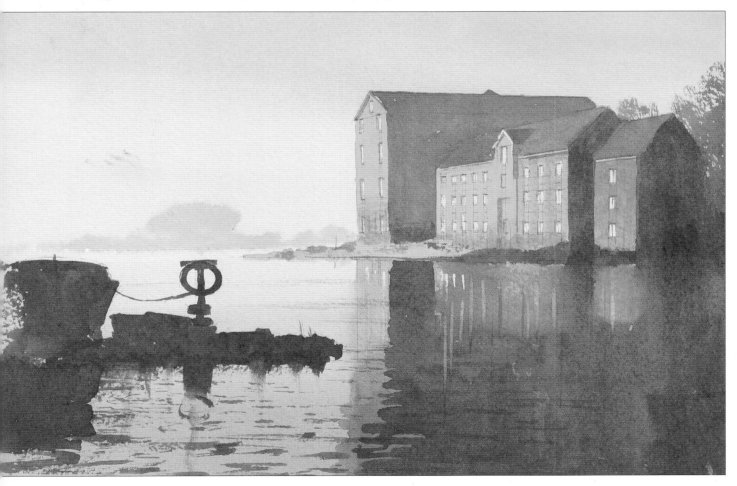

A Claude mirror is a useful device to gain understanding of tone. This is a sheet of glass blackened on one side and used as a mirror. To make one, paint a rectangle of glass with black paint and tape the edges, or use an old picture frame and put a sheet of black card behind the glass. When you look at a scene in the Claude mirror, the reflected tones will be a couple of degrees darker than in reality, and most of the colour will be removed. By exaggerating the tones in this way, the device can help you to see the possibilities of a subject. You need to paint facing your mirror, but with the scene you are painting behind you.

CONTRASTING

Contrasting is the technique of placing light shapes against dark and vice versa. I use this principle in most of my paintings to create dramatic effect. As the illustrations below show, simple views can become very picturesque when rendered in this way. The painting of the farmhouse on page 33 is also a good example: the farmhouse itself catches the light and contrasts starkly with the dark cloudy sky behind it.

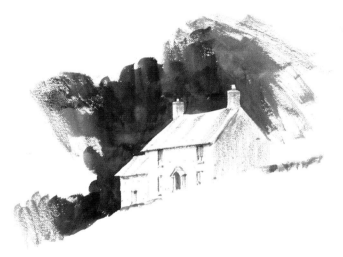

In this picture the house catches the light and creates a contrast with the darkness behind it.

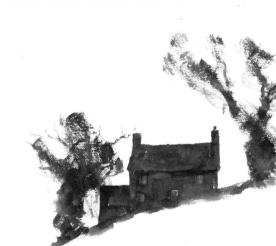

Here the dark house and trees are contrasted with the much lighter background.

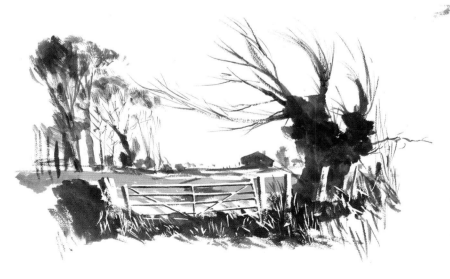

In this more complex picture, the fence and gate contrast with the darker middle ground, and the silhouetted trees with the lighter skyline.

Basic techniques

PAPER STRETCHING

Paper has to remain absolutely flat for wash techniques to work successfully, so you must avoid the puckering and shrinking that can occur when areas of the paper get wet. Heavy grades of paper such as 300gsm will remain flat when water is brushed onto it, so stretching this paper is unnecessary. Thinner papers will develop an uneven surface, making the application of an even wash impossible. To prevent this, the paper is soaked, laid on a board and taped down with gummed tape so that as it dries, it is prevented from shrinking. The end result is a sheet of paper that is as tight as a drum and perfectly flat, waiting for all those wash techniques.

The most popular way to stretch paper is to place gummed tape around the edge of the wet paper on the board. For one reason or another, this method does not always work, so here are some alternative suggestions to achieve success. I run a little wood glue around the edge of my paper before taping it down with gummed tape. Another simple method is to use a roll of cash receipt paper as tape, and stick it with ordinary PVA glue. This worked well for me in Northern Australia, where the gummed tape was ruined by the humidity. Some receipt rolls are of newspaper quality, but these are not strong enough, so go for the better quality.

1 Soak the paper in water.

2 Lay the wet paper on a board. You can then run a little wood glue around the edges of the paper as an added precaution. Wet strips of gummed tape and tape the paper to the board.

3 The paper is unable to shrink, and when it dries it will be drum-tight and perfectly flat.

WASH TECHNIQUES

Painting a large, flat area of colour is called applying a wash, and is fairly straightforward, but becomes more complicated as you add further washes and experiment with the possibilities that this technique opens up.

A basic wash

Start by mixing the colours in a palette. Make sure you have mixed enough colour before you start, because it will be difficult to mix more colour once painting has started. The small tray with your tin of paints may not be big enough. Prop the edge of your board up a little, and with your largest brush, run a bead of paint along the top edge of the paper. Re-charge the brush and run it below the first line, so that the two lines run together. Continue down the paper in the same way until you reach the bottom. The last line will leave a large bead of wash at the edge of the painting, which can be removed with the brush or with some paper tissue applied to the edge of the paper.

Now you can see the possibilities of this technique. What if you mix two colours on the paper, or paint one wash over another? There is plenty of room for experimentation.

A granular wash

Granular colours such as raw sienna, burnt sienna, burnt umber, cobalt blue and ultramarine blue tend to accentuate the texture of the paper as the particles fall into the hollows of the paper surface. This can create a useful effect.

A graded wash

A graded wash is applied in the same way as a basic wash, only clear water is added, diluting the wash and creating a blending effect from colour to clear paper.

A mixed wash

A smooth wash

However, if you prefer a smoother finish, try drying the painting face down.

Wet in wet

Once you have experimented with wash techniques, it is only natural to wonder what will happen if a brush full of paint is placed on to the still wet wash. This can be very exciting, as the new colour spreads out across the paper, gently mixing with the first colour. The board can be tilted to encourage the introduced colour to move this way and that to create whatever effect is desired. You can, however, come across one of the big risks of the wet in wet technique. The colours do not always blend evenly as expected, but sometimes form ridges or hard edges which can ruin a painting.

The cause of hard edges is uneven drying. A completed wash should dry evenly, so it is important to keep the board level during drying. However, if further brushfuls of paint are added during the drying process, then the area that has just received the paint will be a lot wetter, and as the painting dries, there will be pools of wet against the dried wash. This is a difficult area to instruct in, as factors such as different papers can affect the outcome, so hands-on experience is best for finding solutions.

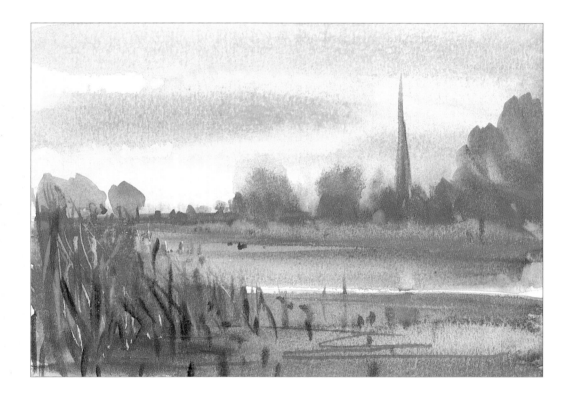

Fenland Scene
190 x 135mm (7½ x 5¼in)
This painting was carried out at speed, working into a wet surface. Only the church spire and some trees to the right were added when the painting was dry.

Hard edges can form strange and beautiful patterns, but can also ruin a painting if they are unplanned.

22

The painting shown below of a view across fields gives a good example of working wet in wet. Most of the scene was worked by adding brushfuls of paint to a wet surface, enabling me to capture the skyscape quickly. The paper was brushed from top to bottom with a wash of raw sienna and a touch of scarlet lake. While the wash was wet, a dilute mix of cerulean blue was brushed into the sky area, with areas left out for the clouds. While the paper was still wet, I painted the clouds with a mix of ultramarine blue and alizarin crimson. The colours mixed on the paper. I left gaps where the warm colours of the initial wash of raw sienna and scarlet lake shine through as the sunlit edges of the clouds.

The wet in wet process was continued in the lower section of the painting. Another wash of raw sienna and crimson lake was added and the dark shades in the fields were introduced with a mix of alizarin crimson, Prussian blue and burnt sienna.

The main groundwork of the painting was now allowed to dry. The rest of the painting was continued as normal, brushing in detail and using dry brush techniques to create the ragged edges of foliage and to develop the texture of the fields.

A View Across Fields

270 x 210mm (10½ x 8¼in)
The wet in wet technique was used to capture the sky and the
foreground of this painting. Details and texture were added later.

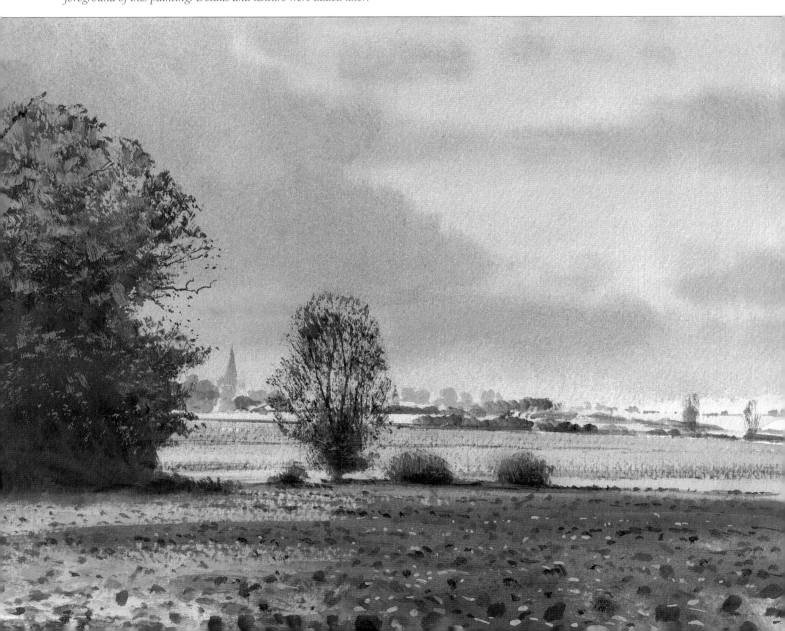

The dry brush technique

For dry brush work, we remove excess paint from the brush so that there is just enough left to make a mark on the paper. The brush can then be dragged and rubbed on the paper to impart some useful textural effects. Getting the right amount of paint on the brush is tricky: too much and a heavy blob will be deposited on the paper, too little and no mark will be made. A lot of time is spent removing paint from the brush in between actively painting. To get the wetness of the brush right, dab your brush against the edge of the palette and then touch a paper tissue to the edge of the hairs near the ferrule, to take away more water without removing any paint.

The technique is useful for any area where texture is required: a brick wall, the ragged outline of trees or a ploughed field. It can be employed with a fine brush to do very detailed work, and with a large brush where the broken paint surface could give the speckle of light on an expanse of water. It works best on paper with a textured surface.

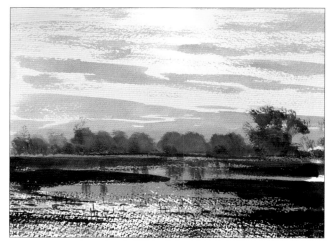

Right: heavily textured papers give a more broken quality to dry brush work. Here the brush has been dragged across the background, leaving a speckle of paint. Above right: dry brush is very effective for textured surfaces like brick and stone.

Other techniques

Most effects are produced with the brush, but there are other tools and techniques that can be very helpful to convey a range of qualities.

Scratching out
Paint can be scratched from the surface of a painting with a razor blade, craft knife or penknife. Wait until the paint is nearly dry – this is when it loses its shine. If scratched out too early, the marks on the paper will fill in with colour and dark lines will be produced instead of pale scratches. If the painting has dried too much, sweep a brushful of water on to the paper and it will become workable again.

Wax resist
Candle wax can be rubbed on to the paper to form a resist. It is a rather haphazard technique, but I find the speckle of highlight it gives particularly useful for capturing the rugged texture of tree bark, and the roughness of stone walls.

Rubbing out
The eraser can be used to remove some paint, to produce highlights. I find it very effective in creating soft highlights on water. If rubbed along the edge of a ruler, straight highlight can be made. A stronger highli he achieved if the p uifed with a razor blade first. Even fine sandpaper can be used in the same way as an eraser.

Masking fluid
The liquid is brushed on to the paper and dries to a latex resist. When you want to remove it, it can be rubbed away with a finger or an eraser. It is best to use an old brush to paint it on, as it tends to gum up brushes.

Dabbing
This is a technique for adding texture, and is particularly good for giving a soft, irregular outline to trees and foliage. After painting an area, dab it with a sponge, some screwed-up paper tissue or a piece of cloth. This technique requires some experimentation.

Spattering
The effects of spattering can be very varied, depending on how it is done. The easiest way to achieve a fine spatter of paint is to tap the brush against a finger. Another way is to charge a bristle brush with paint and to drag your thumb across the bristles. Be sure to mask the work area, as paint spots will fly in all directions.

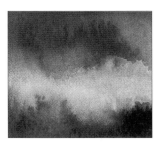

Ox gall
This can be used as a dispersant, to create unusual effects. A touch of ox gall liquid, added to a fluid area of paint, will cause the colours to move rapidly away. The results are unpredictable, but interesting.

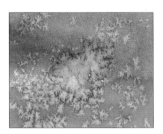

Salt
Normal table salt can be sprinkled into a mix of wet paint. As the salt dissolves, a pattern of spidery shapes appears on the paper. Again, this is a rather unpredictable technique, but it can be very effective. Snow scenes are a popular choice of subject for this technique, but I have found it useful in all kinds of areas when I want something a little livelir than a straightforward ash for the background

Sponging
I use the sponge mainly for lifting out large highlights and for clearing an area that has become overworked. Some painters find it particularly good for working in sky effects.

Split brush
The brush is encouraged to break up into a number of points: the trick is to find a brush that will readily do this. I find the Chinese brushes work best. To get the hairs to splay out, dab the brush into the mixing tray, then dab it up and down on the paper to create a texture of foliage, or broken cloud. Rotate the brush continually in your hand, to avoid making a repetitive pattern. Avoid having too much paint on the brush, as this will produce large blots of paint. Needless to say, this is not a job for your finest sable, and it is best to reserve a brush specially for the task.

Cutting out
Really fine, sharp lines can be cut out of the paper. This is a delicate operation but very effective. Using a sharp craft knife and a ruler, cut two lines close together, making sure you do not cut right through the paper, then peel away the sliver of paper in between. This can be used as a rescuing technique where a highlight should have been left on the paper, but has been painted over.

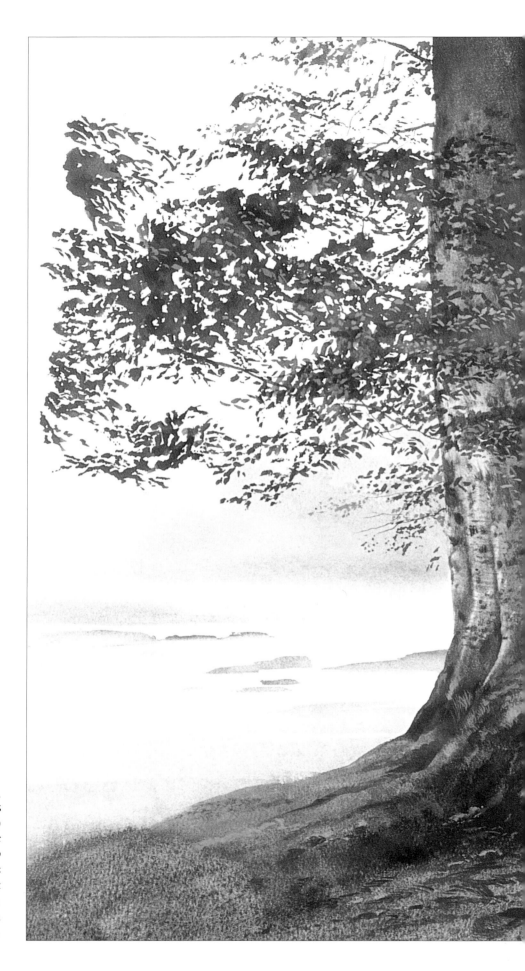

Footpath Beside the Wye, Mid-Wales

600 x 390mm (23½ x 15½in)
The sun's rays breaking through the canopy of foliage add a great deal to the atmosphere of the scene. This was achieved by lifting the paint from the paper with a damp sponge. It took a few light strokes to reach the desired result.

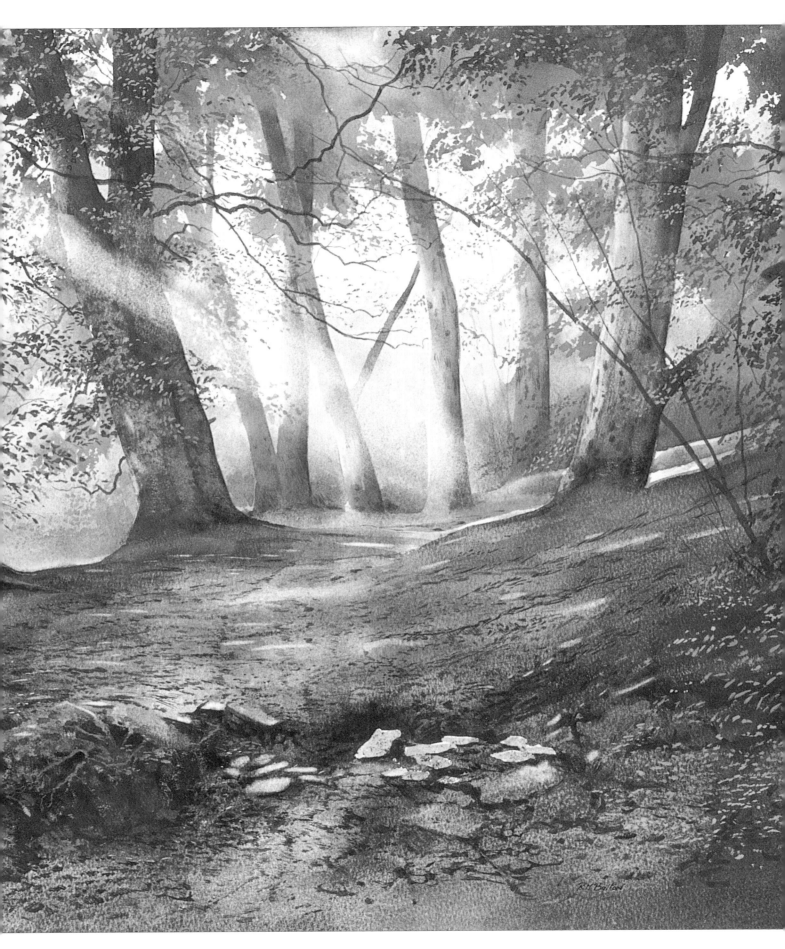

Composition

The bridge at St Ives is a popular subject and has been painted by visiting artists many times over the years. I have observed that they nearly always view it from the same spot, a little way upstream, with the bridge sitting full-square in the middle of the composition, as in the first picture below.

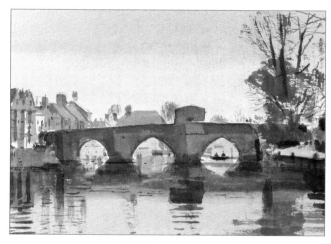

This is a good view but rather obvious, and the fun in composition is to find something a little different that might surprise the viewer and give you a challenge. Taking time to walk around the area throws up a lot of alternative views.

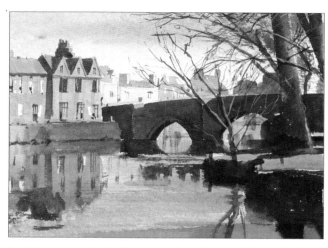

In this view, the bank of trees on the right partially masks the bridge, which I rather like, and the reflections are really exciting, taking full advantage of the buildings.

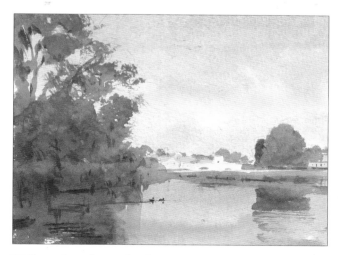

Walking along the riverbank, I get a different view at every turn of the river. Even when I am quite a distance from the bridge, it still leads the eye to the centre of the picture.

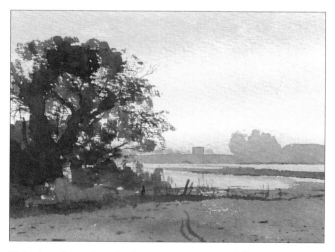

This view shows how looking at a scene on a different day can change everything. Only the silhouette of the bridge is now visible. In nature you do not get straight lines, so even that square shape in the distance is sufficient to draw the eye into the picture and make an effective composition.

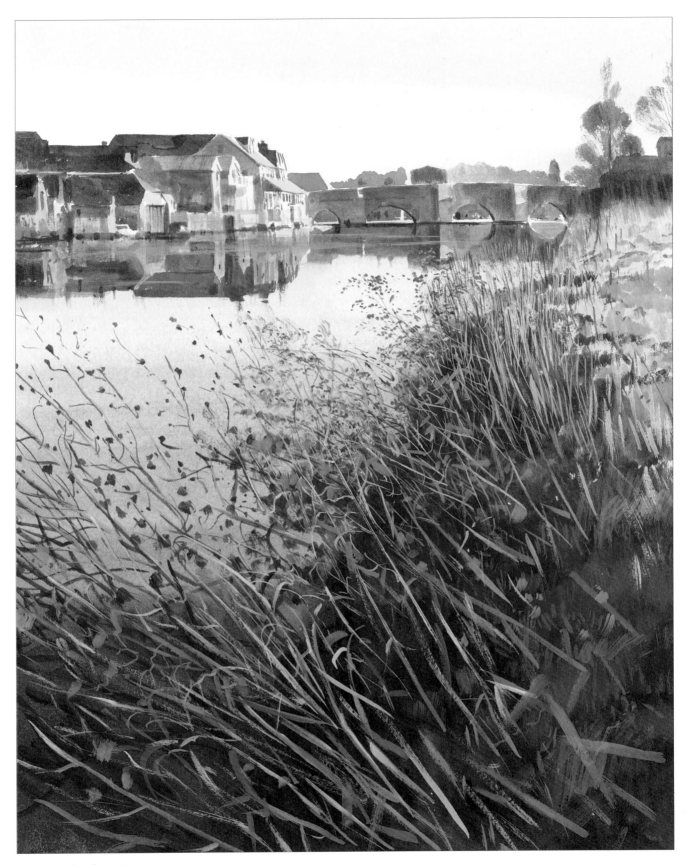

The Riverbank at St Ives

270 x 350mm (10½ x 13¾in)

In this painting the foreground has been used as a compositional aid: the irregular shapes here contrast well with the geometric lines of the old town on the horizon.

Perspective

To get a feeling of distance, it might help to divide the painting into sections: foreground, middle distance and distance, rather like a theatrical set. In landscapes, stronger colours and detail will be in the foreground and more delicate shapes are needed in the background. I always paint from the background, forwards. This makes practical sense, since you are laying stronger colours over lighter ones. For this reason, most paintings begin with the sky.

In order to create a feeling of distance, the background needs to be painted with sensitivity. Overworking or hard edges will destroy the illusion of distance. Colours become more muted when viewed from far away, edges are less distinct, and the atmosphere tends to lend blueness to the distant view.

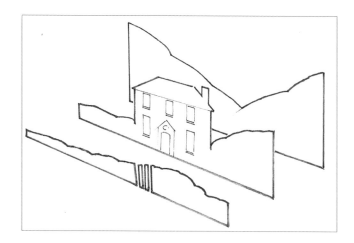

The first example (top) has been poorly painted. The use of too much water has caused lots of hard edges to form, and the sense of distance is lost. In the bottom example I have kept the edges soft and the appearance of distance is much stronger.

FIGURES

Figures in landscape can cause major problems of proportion, and getting the scale right is difficult. I use a simple drawing device that, if kept in mind, should be a great help. With your eye level on the horizon, all figures should be approximately on the same eye level line. However far away they are, they will then fit in the painting. This trick works if you are painting a level surface – things become more difficult if there are gradients!

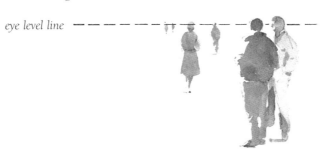

eye level line — — — — — — — —

My simple drawing device for placing figures in a landscape.

REFLECTIONS

Reflections are a rewarding subject to tackle, but can be confusing. It is rare to get a perfect mirror image as shown in the drawings – usually there is some disturbance that can have all kinds of effects. Be sure to pay particular attention to the vertical lines in the reflection, which should match up with the scene above.

An easy way to picture how reflections work is to think of an object with half the view above the water and its identical self upside down underneath.

This scene shows the church with its reflection, which is the same image inverted. Note that, when the water line is not visible (as above) or the reflected object is set back from it, you need to imagine the water surface extending to the base of the object. The imagined mirror image begins at the base of the object, but of course only the part that is in the water is drawn.

Reflections in puddles follow the same rules as any other reflections: the image of this spired church is inverted below the horizon line.

Buildings

Architectural subjects can tax our drawing skills, though usually in a predominantly landscape scene this is not a great problem. Buildings can be a great help in a landscape setting: the contrast between the regular lines in architecture and those of nature can enhance a painting and give a useful focal point to a scene. As is often the case, small details can bring a painting of this kind to life. Patches of rust on a tin roof, the fine woodwork round a window or the texture of brickwork can all be used to great effect. It helps to pay attention to detail at the drawing stage: the angle of window sashes and the size of doors and windows are best worked out before committing to paint.

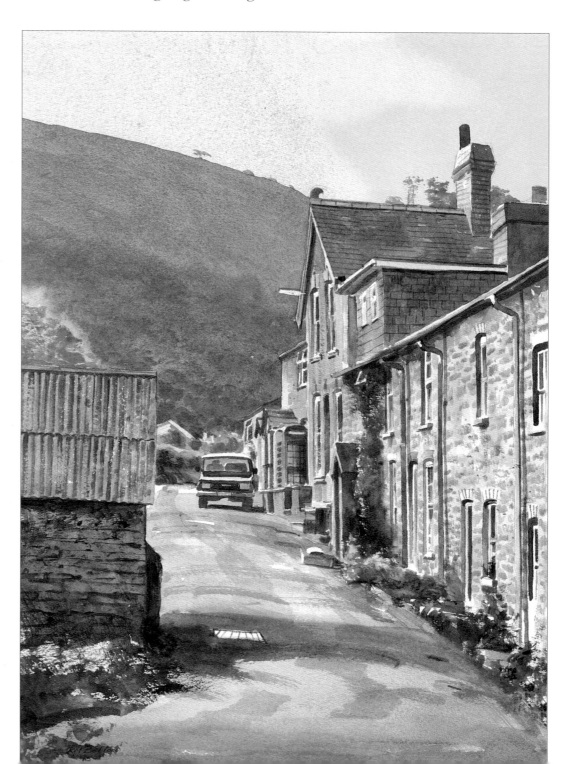

Hillside Village

210 x 315mm (8¼ x 12½in)
In this painting, the terrace of housing on a Welsh hillside gives quite a complicated arrangement of doors and windows. I took care at the drawing stage to get the proportions and perspective right. The thin white lines of sashes and window frames require some delicate brushwork. It is possible to use masking fluid but better results are achieved by using a fine brush and painting the windows in, leaving the white of the paper for the sashes. Manhole covers and irregularities in the road add charm to the scene.

Cars are an interesting addition to a painting. They are such a part of our lives that it is hard to avoid them, but great care is needed: a badly painted car will really catch the eye.

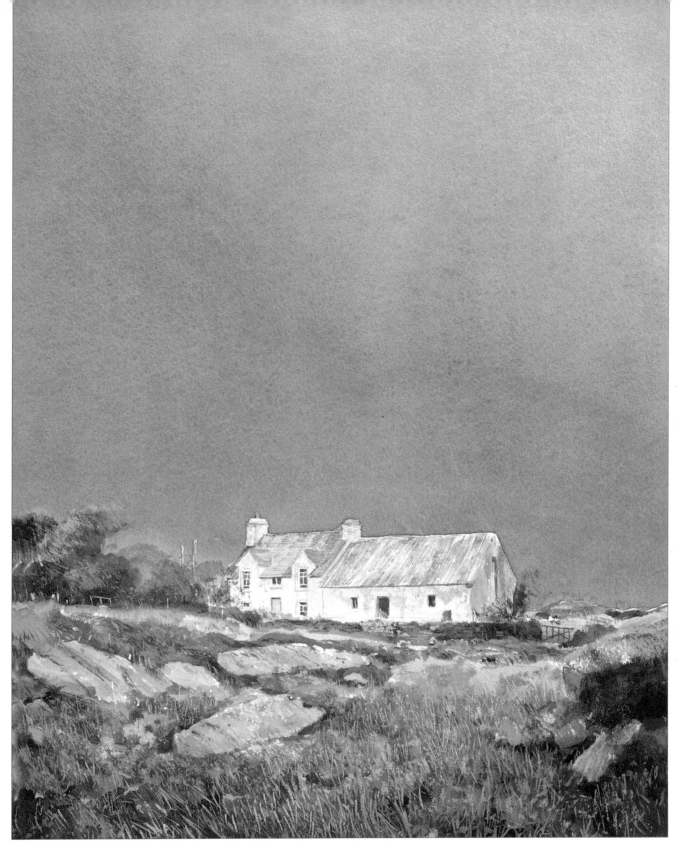

Farmhouse

255 x 345mm (10 x 13½in)

In this painting, the dark clouds contrast with the face of the old farmhouse to dramatic effect. Masking fluid was used to paint out the house before I started working on the sky. The sky was completed in a couple of washes: firstly cerulean blue and a little alizarin crimson, which, when dry, was followed by ultramarine blue, alizarin crimson and a little burnt sienna. The darkest part of the sky wash appears behind the house to emphasise the contrast.

Wax resist and then masking fluid were applied to the foreground to give texture to the rocks and to mask them against a couple of brushfuls of raw sienna. Indian red and burnt sienna gave me the rust colours amongst the heather, and this was followed by some scratching out with the corner of a razor blade while the colours were still damp, to introduce the fine stalks of grass.

Figures and animals

If your painting is going to include a figure in the foreground, you should get a model to stand for you, or take some photographs to enable you to portray the figure convincingly. Figures that are in the middle ground or in the distance are sufficiently far away to enable the painter to make them up. However, this is an area in which a lot of skill is involved, and poor figure work can let down an otherwise good painting. Figures are the first thing that captures our attention in a painting, so plenty of practice in this area can make quite a difference.

All artists develop their own ways of handling this subject. Here are two ways in which I introduce figures on to a dark background.

Masking fluid

You can mask out the figure at the planning stage of the painting, and this will give you a sharp white background to work on later. However, the sharp edges can make the figure look a little unnatural. For this reason, it is sometimes better to mask out only the highlights of the figure's head and shoulders.

Opaque colour

My preferred method is to paint out the shape of the figure in opaque Naples yellow, and then work with my transparent colours over this. It is easier to make changes with this method than with the masking fluid technique, and I prefer the softer look. The base colour of Naples yellow can be adapted as necessary by adding colours from the tray, so if a grey is needed, then a little red and blue gives me the appropriate mix.

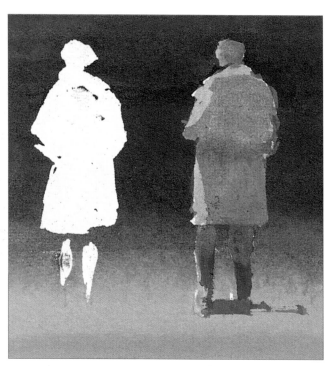

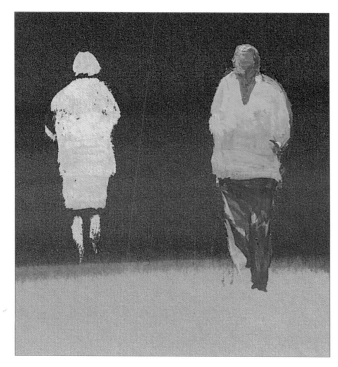

TIP

If you are not confident with the scale of the figures you wish to introduce, try cutting them out of paper and moving them around on your sketch before drawing them.

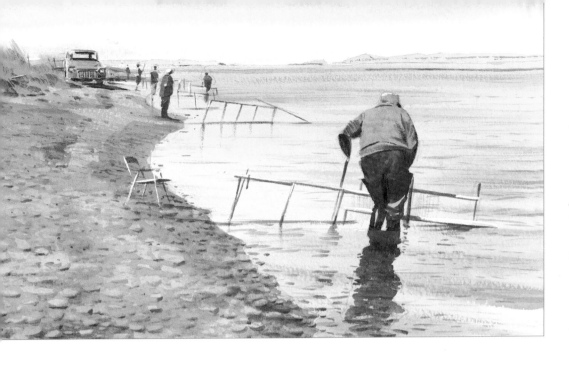

Whitebait Fishermen on the Opihi River, New Zealand

280 x 170mm (11 x 6¾in)
Here I painted the water as though the main figure was not there. I used masking fluid to retain highlights on the fisherman's hat and the net supports. The fisherman and his reflection were then painted in. This way, the water continues smoothly across the view without any interruptions which might have appeared had I tried to paint around the fisherman.

Cattle Grazing on the Banks of the River Ouse

580 x 390mm (22¾ x 15½in)
Most landscapes are complemented by the introduction of animal life. In this rural scene, the cattle were introduced by overpainting with Naples yellow. First their shapes were painted in, and then when I felt that their outlines were right, the colours and tone were introduced.

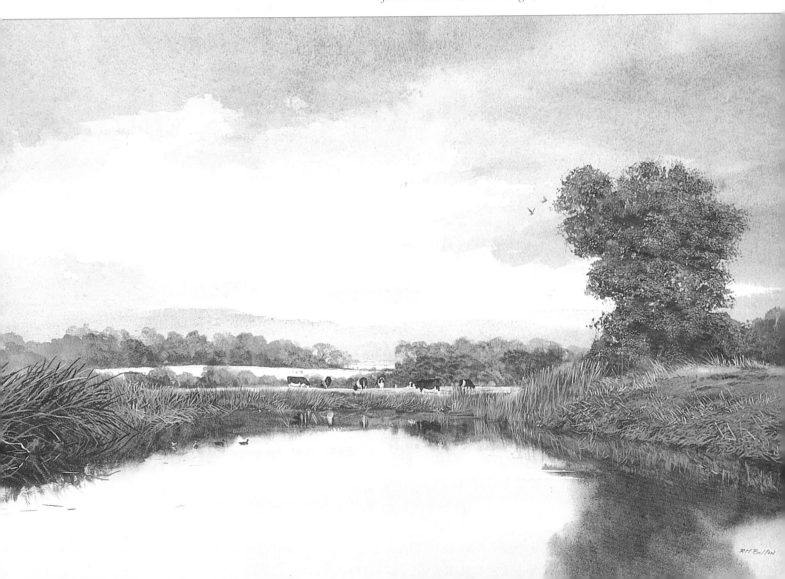

Atmosphere

Atmosphere is an intangible quality bound up with light and colour. There are some days that are perfect, and in every direction you can see possibilities for a painting. On other days there is nothing to inspire you.

Unfortunately, our most pleasant, warm, sunny days are not always the best for providing atmospheric light. In the middle of the day when the sun is overhead, things can look very ordinary, and you might have to use your imagination to make a painting interesting. When weather conditions are more acute, there is likely to be more atmosphere: rain, wind and snow are always valuable ingredients to a painting. It is always worth a good walk after a violent storm: the flooding and reflections can make good subjects. The lighting in winter can be very interesting; the sun never lifts very high in the sky and this can give us some very dramatic lighting effects.

Dried-up Riverbed

540 x 350mm (21¼ x 13¾in)
In this painting, the stones on a dried-up riverbed in Central Australia reflect back the warm glow from the sun while the shadows stretch out from the trees. It works well as a composition: the old riverbed leads us into the picture to a golden bank of undergrowth and a distant glimpse of trees and a hill.

The need to paint stones and pebbles crops up a lot in landscape painting and these subjects are harder to paint than they look. Simply dotting with the brush will not be very convincing: stones are different colours and shapes, and they are also subject to the laws of perspective: they get smaller the further away they are. You have to convey the differences in colour and shape without the painting looking mechanical or overworked.

To get the atmosphere, I chose to paint this scene at the end of the day so that I would benefit from lengthening shadows. At midday, much of this would have been bleached out by bright sunlight.

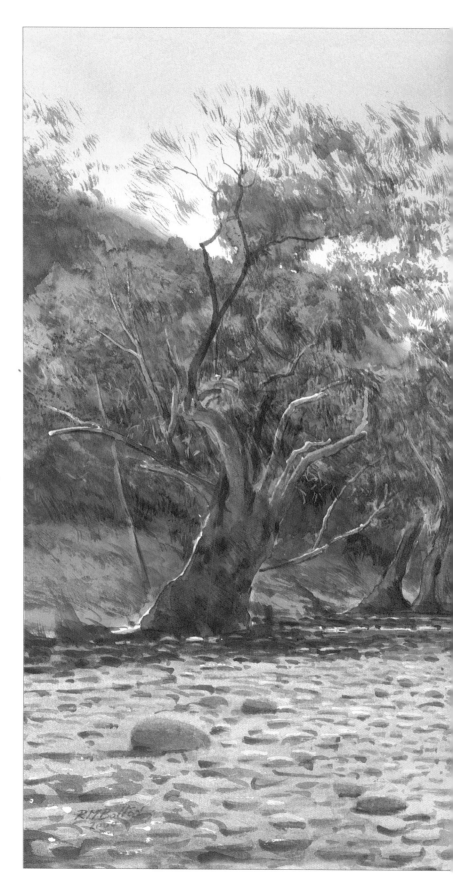

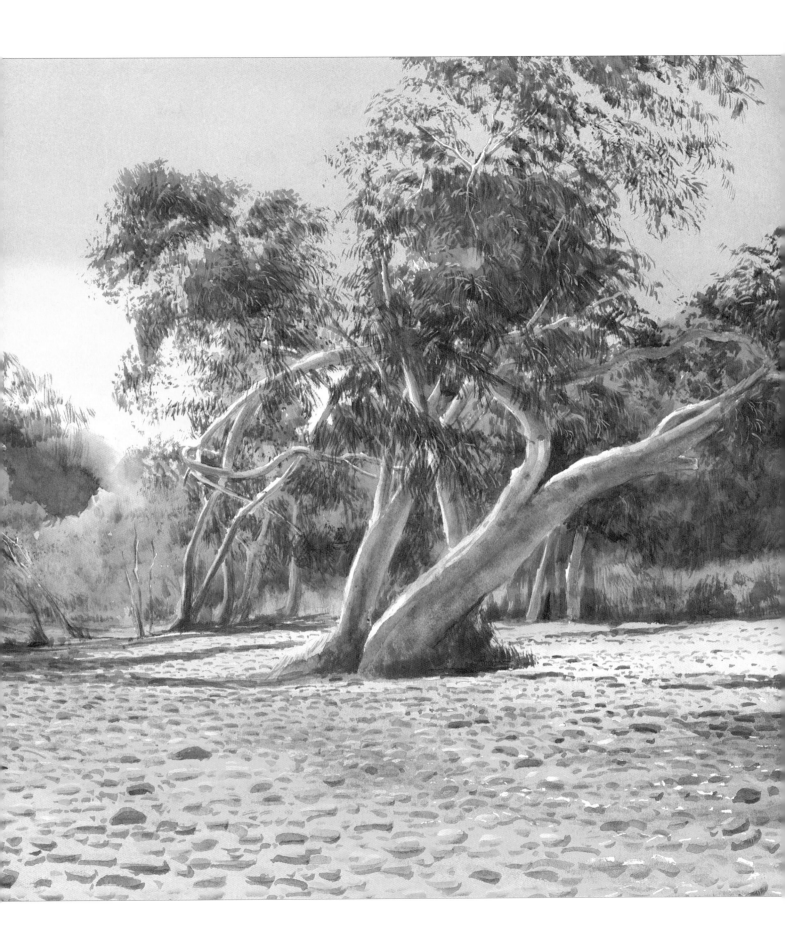

Reflections in the River Wye

565 x 410mm (22¼ x 16¼in)

The rocks reflected in the river in this painting are called 'the devil's shoes', and were a favourite spot for me to scramble up as a child, to see if I could spot a trout. Atmosphere can be found in many ways and here it is the grey, overcast day that has given the painting its tranquil, cool quality. Many of the greys are made from a mix of burnt sienna and cerulean blue. Cerulean blue is a pale blue and is very effective for creating these cool shades. In the background, the paper was brushed with water before applying the colour, so that the colours would feather out and give soft edges. When dry, the same mix of colour was used to give some shape to the background foliage.

In the foreground, ultramarine blue was mixed with burnt sienna to paint the tree trunks and riverbank. Attention was given to the trees to give them shape by adding colours wet in wet and lifting out colours with a small brush to define the crevices and bumps in the bark. There was a lot of green moss on the trunks, and this was added by mixing sap green with burnt sienna and applying the mixture wet into wet. The lighter green of the foliage was mixed from emerald green and Naples yellow, and was then painted on with a small brush.

The river is mostly a mix of burnt sienna and ultramarine blue. A little masking fluid was used to touch out some fine highlights near the foreground. The bands of light across the water were added when the painting was dry. This was done by scratching the paper with a razor blade and using the edge of a ruler to keep the lines straight. The lines were then rubbed with an eraser to bring out their whiteness.

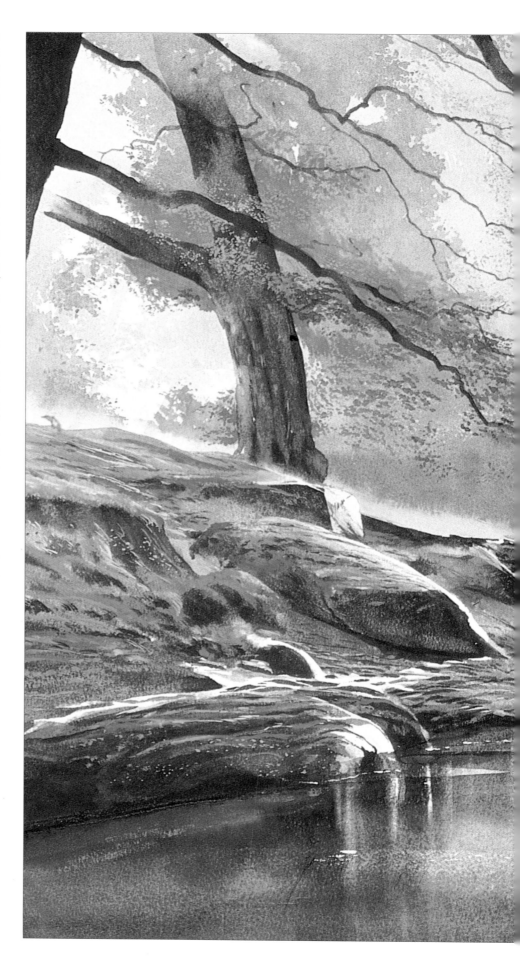

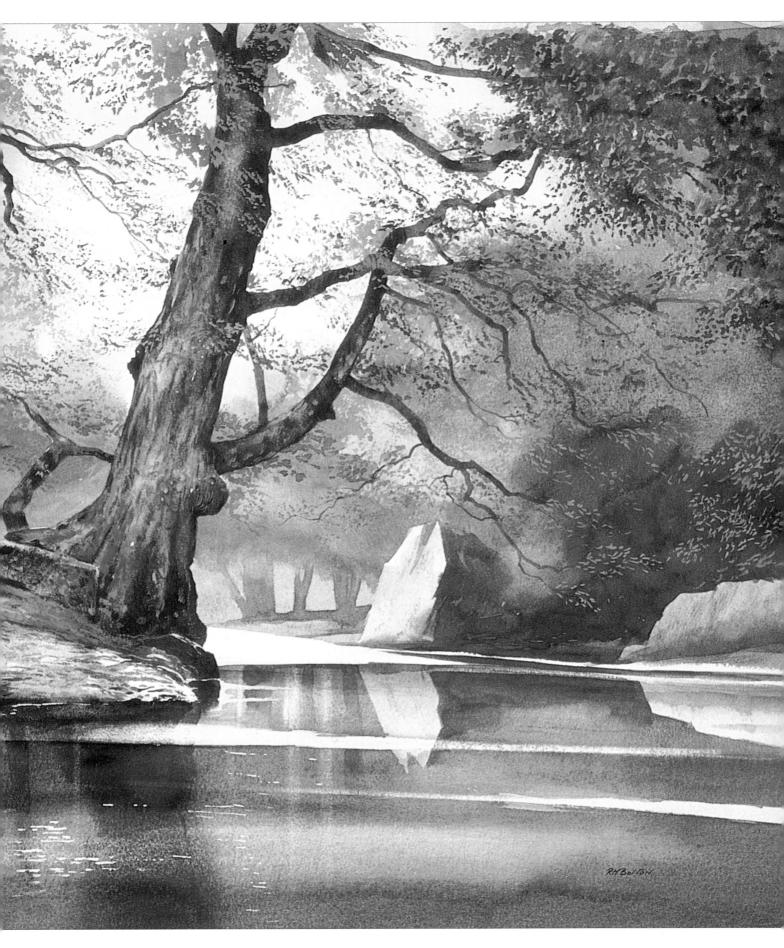

41

Skies

The sky is an ever-present subject that changes from day to day and hour by hour. Its importance to a painting is fundamental, as it is often this that creates the atmosphere and makes a major contribution to the design of the composition. It is best to avoid drawing in the sky area, as lines can show up later, and with some papers, the use of an eraser can leave permanent marks that become evident when you lay a wash.

All the effects of wash painting and wet into wet play a big part in painting skies. It is an area in which you are not in complete control. Colours are brushed in and allowed to mix on the paper. The board is tilted to encourage movement, and you have to react quickly to these changes. Hard edges are always a problem, and having a lot of water on the paper always creates risks, so try to remove some of the excess water by touching the edge of the painting with a paper towel or tissue.

Water Meadow, St Ives

355 x 250mm (14 x 9¾in)
The colours were brushed onto a wet surface to create the softened edges of cloud as the colours mixed on the paper. The background wash is mainly turquoise with a touch of alizarin crimson. While this was wet, a stronger mix of the same colours, this time with more alizarin crimson, was brushed in to form the soft clouds. The sharper lines of clouds in the distance were painted when the sky was dry. The edges could still be softened by running a wet brush along the edge of the paint. To get the smoky colour I added a little raw sienna to the mix.

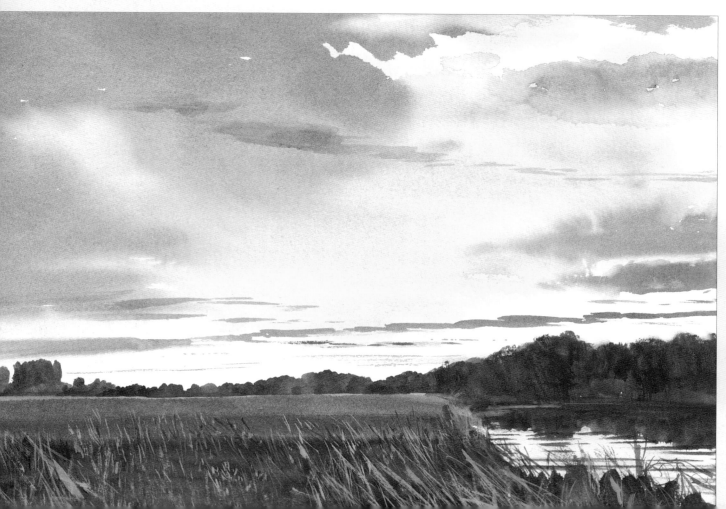

DIFFERENT SKIES

This ragged-edged sky was created using the split brush technique (see page 25), dabbing the brush up and down and splaying the hairs out to give a broken edge.

In the painting on the left, ultramarine blue has been painted into the wet surface of Naples yellow and a touch of alizarin crimson, to blend together softly on the paper.

The sky on the right was created from a base wash of raw sienna and intense blue, followed by a little alizarin crimson and ultramarine blue, which were brushed on to the wet paper. When dry, the harder-edged clouds were added in alizarin crimson and ultramarine blue.

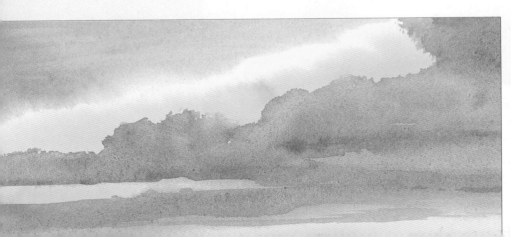

The base wash in the painting on the left was a mix of raw sienna with a touch of scarlet lake, merging into some Winsor blue. While the paper was still wet, ultramarine blue was brushed on to give the dark underside of the clouds.

Sunset on the River Ouse

I often find myself looking up to the sky, noting unusual effects and trying to figure out if I could create them on paper. Sunsets create particularly striking lighting effects to challenge the watercolour artist, and this scene also features the sun's reflection in the water.

Like many sky paintings, this one involves painting wet into wet over an initial wash. You need to paint quickly over a large area to work the sky, and several techniques are required to create the different clouds: some are softer-edged than others.

The reference photograph, which I kept by me whilst painting and referred to for details of tone, colour, form and texture.

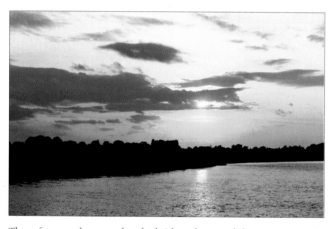

The preliminary sketch. Keep pencil lines to a minimum in the sky area. Lines pressed into the paper can leave unsightly marks if they fill up with paint.

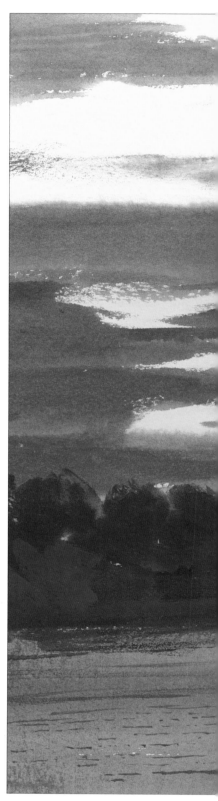

Sunset on the River Ouse
350 x 260mm (13¾ x 10¼in)
The finished painting. The painting of the sky relied on a speedy application of colours and a sureness of approach.

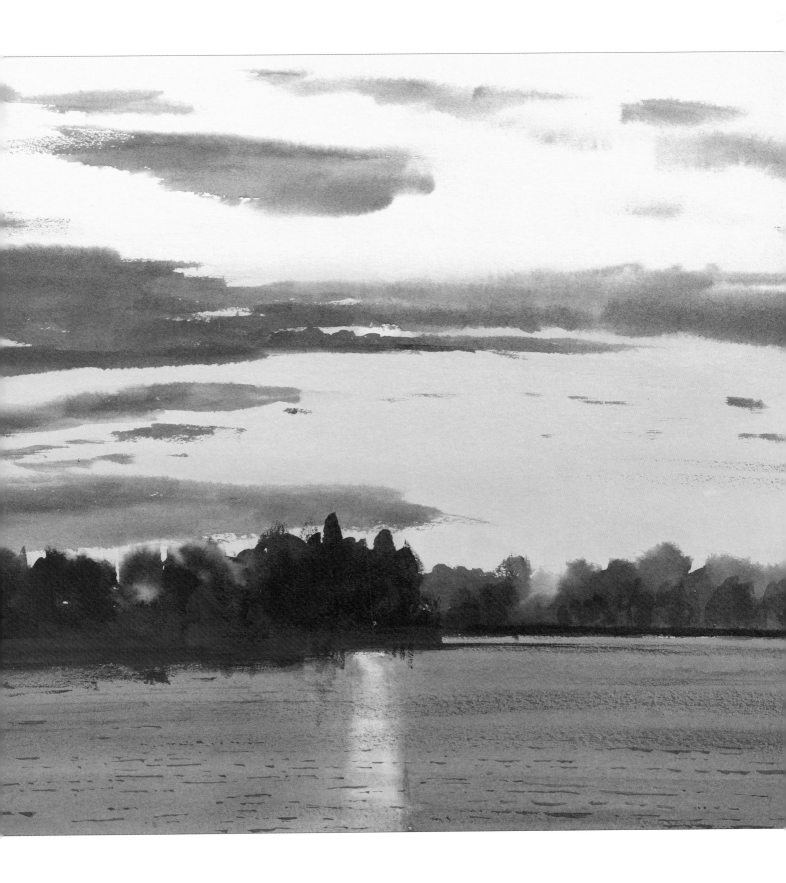

1 Mix a wash of raw sienna, cadmium yellow and a little Naples yellow, with a touch of scarlet lake. Using a large round brush, wash lightly down from the top of the painting, and more darkly down towards the river's edge. Continue over the river area, down to the bottom of the painting, but leave an area white for the sun's reflection. While the wash is still wet, lift out a circle for the sun with a dry brush. Allow the painting to dry.

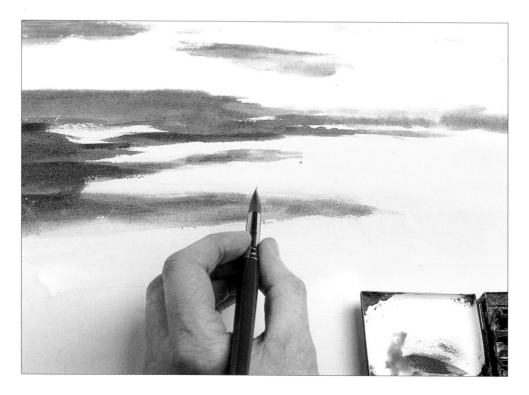

2 Mix together ultramarine blue, cerulean blue and a little scarlet lake. Wet the lighter area of the sky, and paint in the blue clouds with this mix and a size 12 brush. Darken the mix for the clouds in the middle of the painting, and soften their edges using a wet brush.

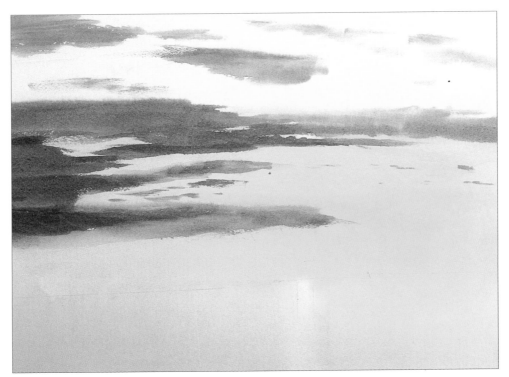

3 Finish painting in the dark areas of cloud, then allow the painting to dry. Note that the dark blue dries much lighter, as shown in the next picture.

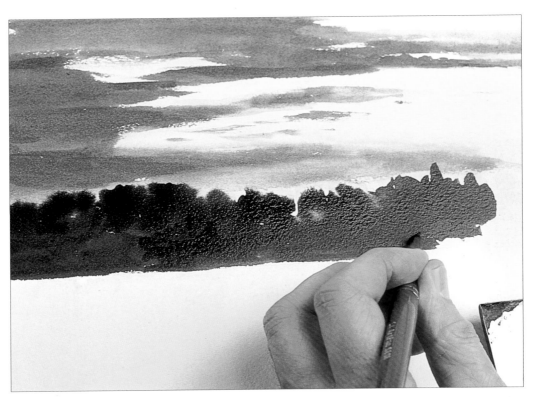

4 Make a dark mix of Prussian blue and Indian red for the foliage on the riverbank, but don't mix the colours too thoroughly, as the foliage will look more realisitic if the shades vary. Paint in the foliage using a size 12 brush.

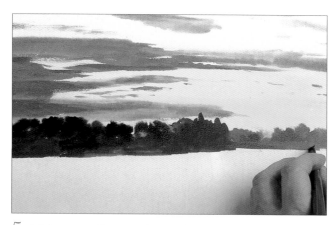

5 Add opaque Chinese white to the mix, and paint in the background trees. The milkier blue will automatically make these trees look more distant.

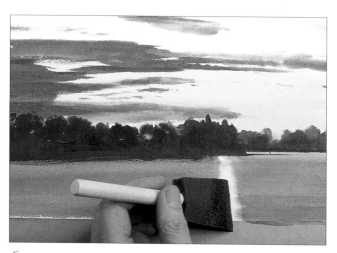

6 Make a greyish mix using cerulean blue, ultramarine and scarlet lake for the water. Wet the foreground, and then wash on the mix using the large round brush. Lift out the sunlit area of the water using a sponge brush as shown.

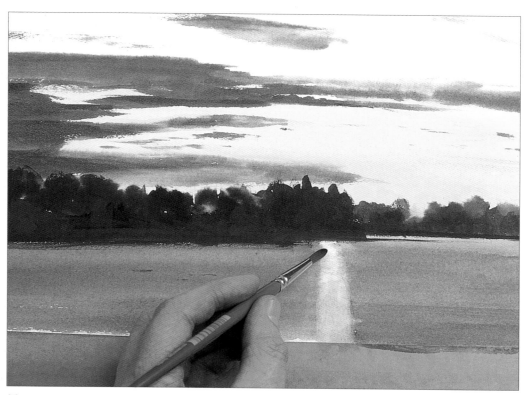

7 Paint in the orange tint in the sun's reflection using a mix of crimson lake and cadmium yellow and a size 6 brush, then soften the edges using clear water.

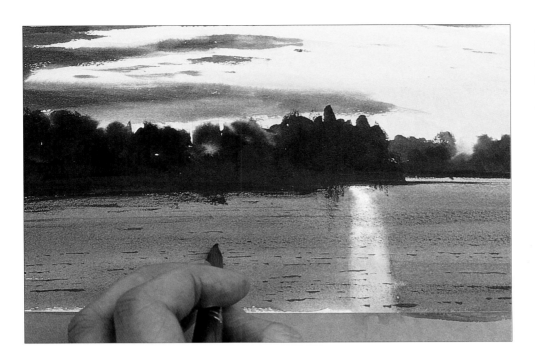

8 Mix Prussian blue and Indian red, and with the tip of a brush, paint in the shadow on the water and the finer details of the water's surface.

The Ouse at Great Barford

570 x 390mm (22½ x 15½in)

The sky in this scene was made in three layers of wash. The first was Naples yellow, leaving a clear highlight in the centre. The second layer of colour was ultramarine blue softened by a brush along the painted edge. With the third wash, a mix of ultramarine with a touch of burnt sienna, some edges were left sharp and others were softened.

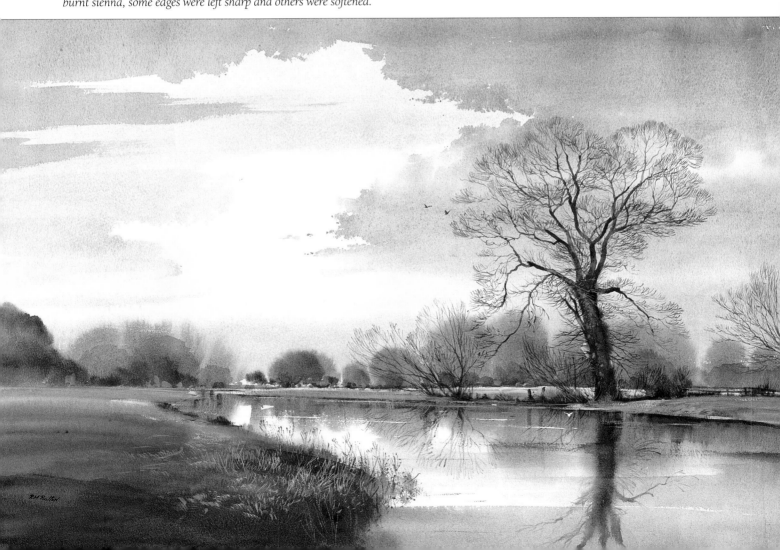

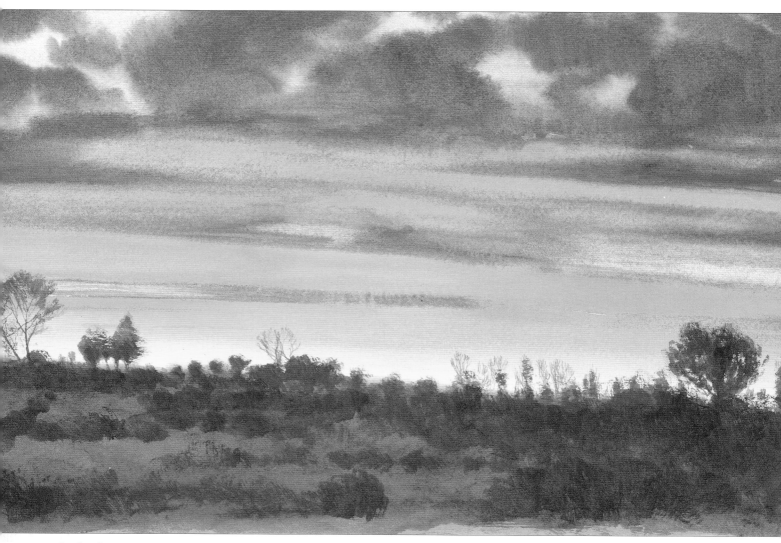

Outback Sunset

350 x 230mm (13¾ x 9in)

To capture this effect, the sky was painted quickly wet in wet: the bands of orange and pink first and the background blue sky second. While the wash was still wet, a brush was dragged a couple of times across the sunlit bands to soften and blend the colours. Working like this can be a bit unpredictable, and a careful eye should be kept on the painting as it dries, to look out for darker colours drifting into the lighter sections.

Evening Sky

340 x 240mm (13½ x 9½in)

Dramatic skies are often cast just before sundown. The soft qualities of this scene were achieved by painting wet into wet, followed by some work with a fine brush to add the wisps of cloud. There is often a band of light on the horizon in sky paintings; this is very useful here as it accentuates the silhouette of the tree line.

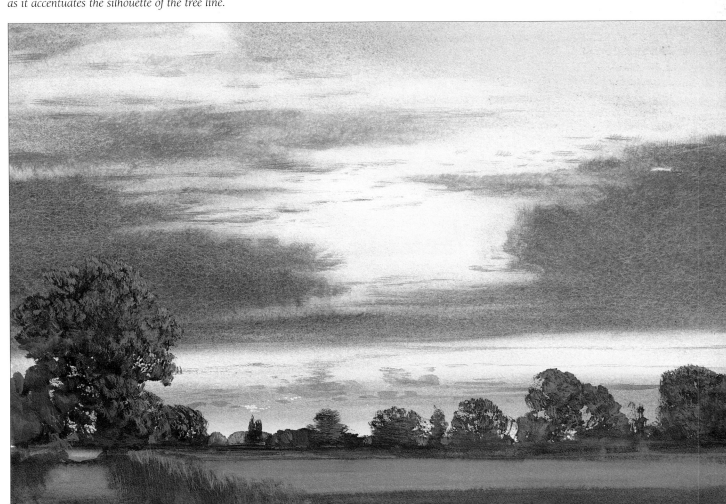

Trees and foliage

Trees are a major component in landscape painting, and are likely to feature in most of the scenes you wish to paint. A winter landscape of trees can be spectacular with all the branches and twigs exposed, and since there is no foliage, a lot more scenery is on show. This all changes in the summer as the landscape becomes draped in green. This is a taxing area for the watercolour painter: large areas of green can look lurid in a painting, so a good deal of sensitivity is required to make it work. Our preconceptions can also get in the way: we automatically think trees are green, and mix colours accordingly. In my experience, I find I need to mix less green than I think I need – so if I am mixing viridian and Indian red for a dark shade of foliage, I will only need to add a little viridian. A few flecks of bright green added later as overpainting may be all that is needed.

It really pays to study previous masters of watercolour to see how they painted this challenging subject; every painter seems to have developed a characteristic style of his or her own.

There are many ways of approaching a subject, and using a variety of techniques, as shown on the opposite page, you can create a range of subtly different qualities.

The Spreading Oak
450 x 280mm (17¾ x 11in)
The split brush technique is well illustrated in this painting. To form a ragged edge of foliage, the brush tip was splayed out into a number of points and then dabbed gently on to the paper to create the patchwork of leaves.

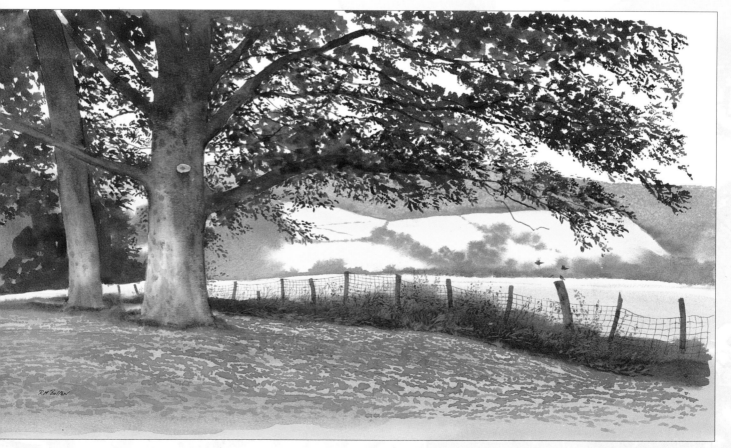

Foliage

The wet in wet technique (see pages 22–23) gives a soft, moody quality and works well in the distance and mid-ground. In the foreground, more work is needed to show the build-up of leaves and twigs.

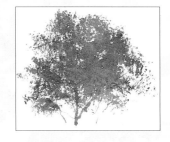

Dry brush is a very effective technique (see page 24), and the texture of the paper can be used to give the broken quality of foliage.

The split brush technique (see page 25). The hairs of the brush are splayed out and then dabbed up and down of the surface of the paper, giving a convincing dappled quality to the foliage. Rotate the brush continually in your hand, to avoid making a repetitive pattern, and avoid having too much paint on the brush.

Twigs

A very fine brush can be used to paint in all the detail of twigs. The rigger brush can be very useful in this area, and its long hairs are excellent for lots of sweeping, thin lines.

A less time-consuming way to paint twigs is with the dry brush technique. You have to be sure that all excess paint has been removed from the brush before painting, as a mistake here could be costly.

These twigs have been suggested by the wet in wet technique, which can also be very effective.

Trunks

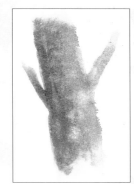

Colours have been dropped into the initial wash on this trunk wet in wet, to give a suitably mottled look.

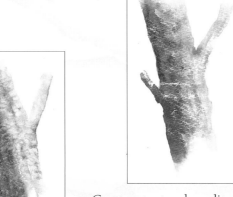

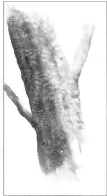

Candle wax works well to impart a textured look. Rub the candle on the paper before painting, and the wax works as a resist.

Create a textural quality by sprinkling salt on to wet paint (see page 25). Here you can see the dappled effect this technique produces in a mix of sap green and burnt sienna.

Summer Afternoon

I was attracted to this scene by the rosy glow from the sun, picked up on the trunk of the tree.

The painting is not an accurate record of the scene: one or two changes have been made to suit my purposes. In particular, some heavy foliage was left out around the base of the tree, in favour of showing more of the woodwork. Detail has been kept to a minimum in favour of a lively approach.

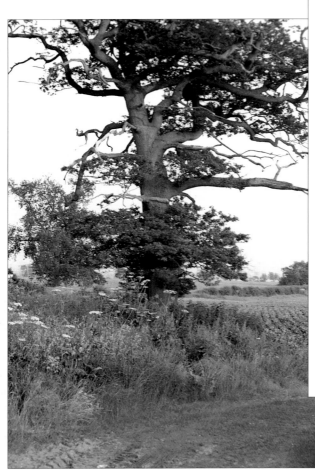

This is the photograph of the scene that inspired the painting. I kept it by me during the painting, referring to it for details, colour and tone. However, as you can see from the painting shown opposite, the finished piece was never intended as a faithful reproduction of the photograph, but as my own interpretation of the scene.

The preliminary sketch. Time spent on the sketch is never wasted. It is much easier to correct an error at this stage than later on. In particular, check that the scale of the branches and trunk is right – there seems to be a kind of formula to the way branches grow and divide, and it is easy to get the balance wrong. Take a moment to stand back and see if your drawing looks right.

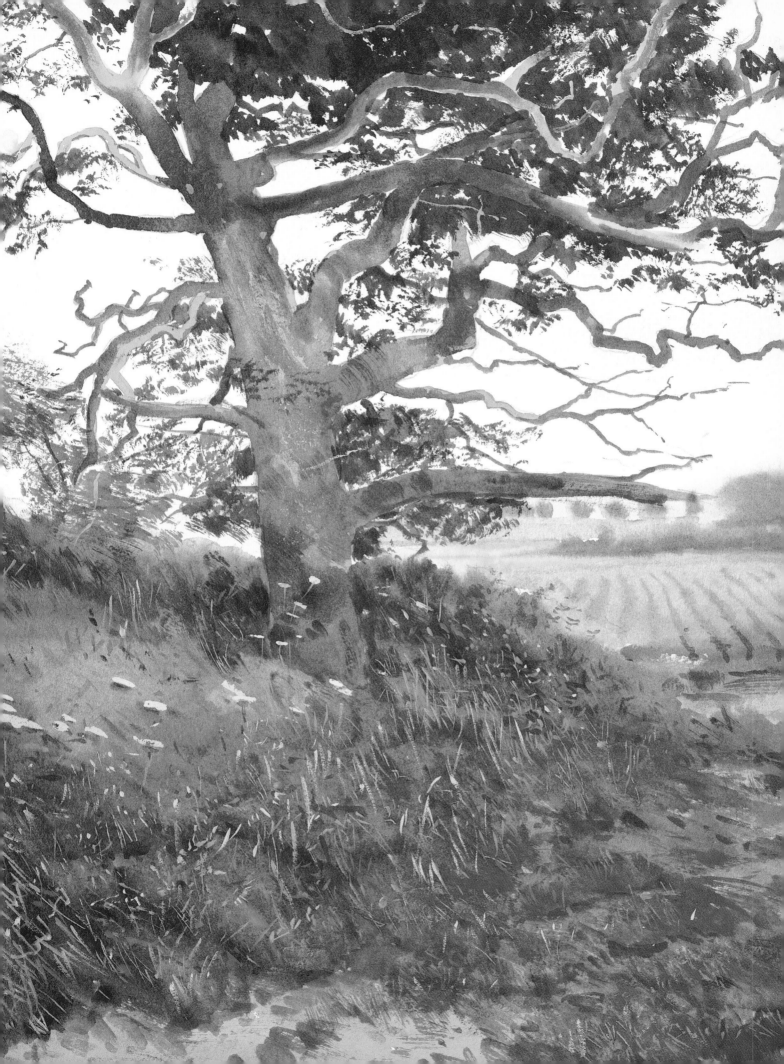

1 Rub candle wax on to the tree trunk. This will add to the texture of the bark when it is painted.

2 Mix a wash with a little alizarin and ultramarine. Take a large wash brush and wash from the top of the picture down to the horizon line. Add a little more blue just above the horizon line; this will create the illusion of distance. Brush over this with clear water.

3 Mix a wash of Naples yellow and raw sienna for the foreground. Wash it on and merge it with the watery edge of the blue.

4 Add more raw sienna to the wash towards the bottom of the picture, creating an earthy tone in the foreground.

5 Using an old brush, paint masking fluid on to the cow parsley heads. This will preserve the colour of the wash in these areas, even when other colours are painted on top.

6 Brush clear water above the horizon line. Using a size 6 brush, paint in the area of the background trees with ultramarine blue and burnt sienna.

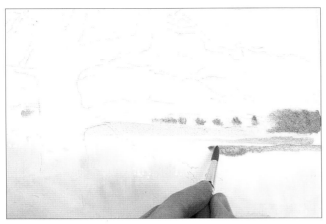

7 Begin to fill in the green of the background fields just below the horizon using emerald green and raw sienna. Remember that you usually need less green in a mix than you think!

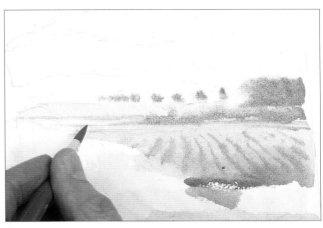

8 Add more ultramarine to the green mix to create the lines of the crop in the field. Painting wet into wet, use burnt sienna mixed with emerald green to paint the distant hedge. Add scarlet lake to the mix to deepen the colour of the earth between the hedge and the field.

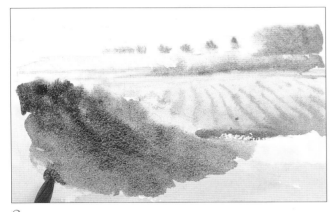

9 Soften the foreground with clear water. Using a size 11 brush, work on the grass with a mix of viridian, raw sienna and burnt sienna.

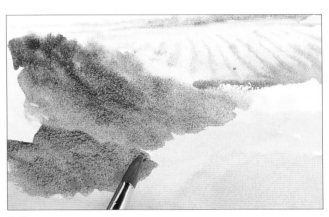

10 Fill in the foreground texture of the grass. The green should be stronger and less brown towards the foreground.

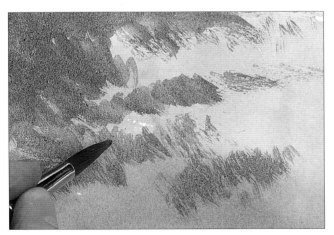

11 Use the dry brush technique, holding the brush on its side and scuffing it over the surface of the dried earthy wash, to create the foreground grasses.

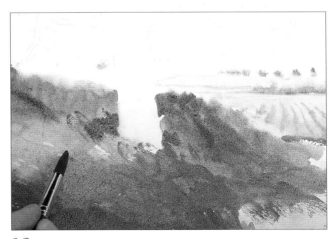

12 Detail the shadow at the base of the tree, and under the flower heads, using a mix of alizarin crimson and a little ultramarine blue.

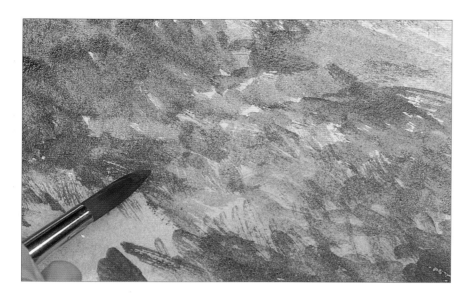

13 Mix scarlet lake with Indian red for a rusty shade of red, and paint the tyre tracks in the mud in the foreground. Add ultramarine blue to the mix for the shadow in the bottom right-hand corner.

14 Develop the colour of the foreground grasses using emerald green for the lighter parts, and for a darker green, ultramarine and viridian. Use a craft knife to scratch out a grassy texture.

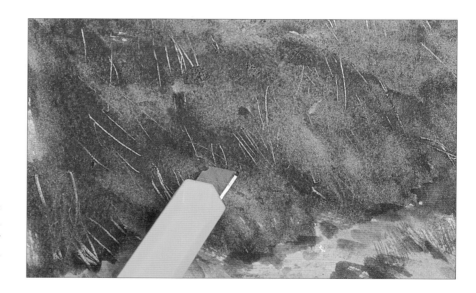

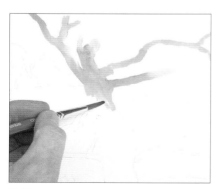

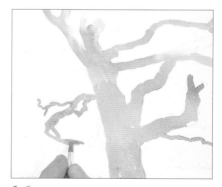

15 Using a size 6 brush, begin to fill in the base colour of the tree: a mix of raw sienna, burnt sienna and scarlet lake. Soften some areas with water first.

16 Continue filling in the finer branches. Vary the strength of the mix, as this will help to suggest the irregular texture of the bark.

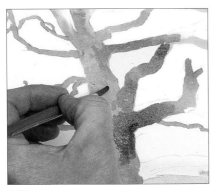

17 Add viridian to the mix and run it in while the paler paint is still wet, to build up the complexity of colours in the bark. The candle wax will begin to show through, adding texture.

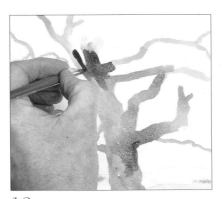

18 Mix ultramarine blue and alizarin crimson to make a purply red for the dark shadows.

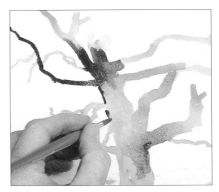

19 Add shadow to the side of the tree and soften the line with a wet brush.

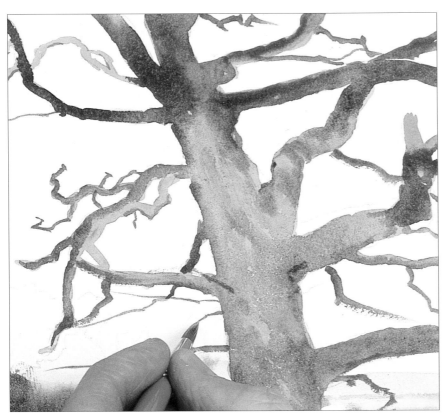

20 Carry on filling in the different colours and textures of the bark, painting wet in wet.

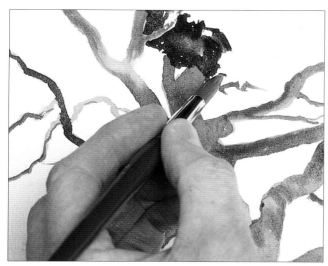

21 Using a size 11 brush, start to paint the dark area of foliage with a mix of alizarin crimson and viridian.

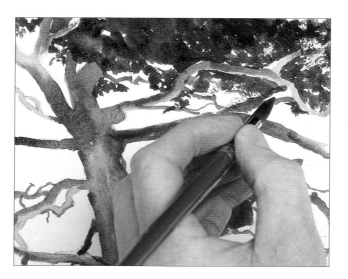

22 Mix alizarin crimson, ultramarine blue, viridian and raw sienna and paint in the rest of the foliage.

23 Using very little viridian, but lots of alizarin crimson, scuff paint on using the dry brush technique to suggest the texture of leaves. Add burnt sienna to counteract the mauvness of the foliage that needs to look greener. The split brush technique is used to paint in the finer leaves against the sky.

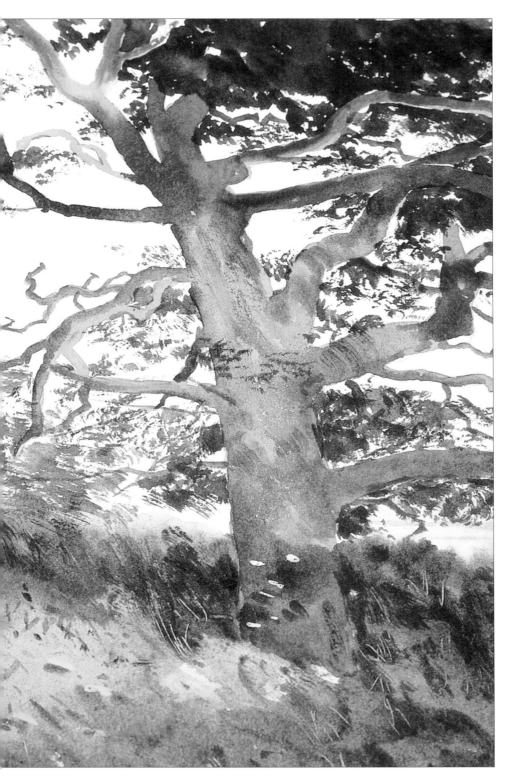

The painting almost complete. When you have come to the end of the above steps, it is well worth standing back to see how the painting works from a distance. Weaknesses can then be approached and adjustments made. I have also picked out a few details in the finished piece (right, and on page 55): some shadows among the branches have been emphasised, and touches of paint have been added to capture random leaves or twigs. I have overpainted some yellow grasses using opaque Naples yellow.

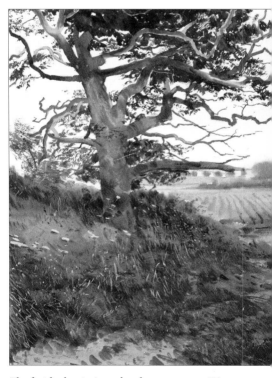

The finished painting, also shown on page 55

61

Gum Tree

345 x 520mm (13½ x 20½in)

The twists and turns of a tree can make a good composition. This Australian gum tree seems to spiral out of the ground, the exposed roots adding to this effect. The rich, warm colours are mostly burnt sienna and raw sienna, while on the distant riverbank a soft haze of foliage has been suggested by sprinkling a little table salt into the wet paint. It is important in a painting like this to get a good contrast between foreground and background, so I avoided unnecessary detail in the background, to give emphasis to the tree. The foliage in the upper branches is mostly burnt sienna and viridian, but many individual leaves have been picked out with opaque Naples yellow, mixed with a little emerald green.

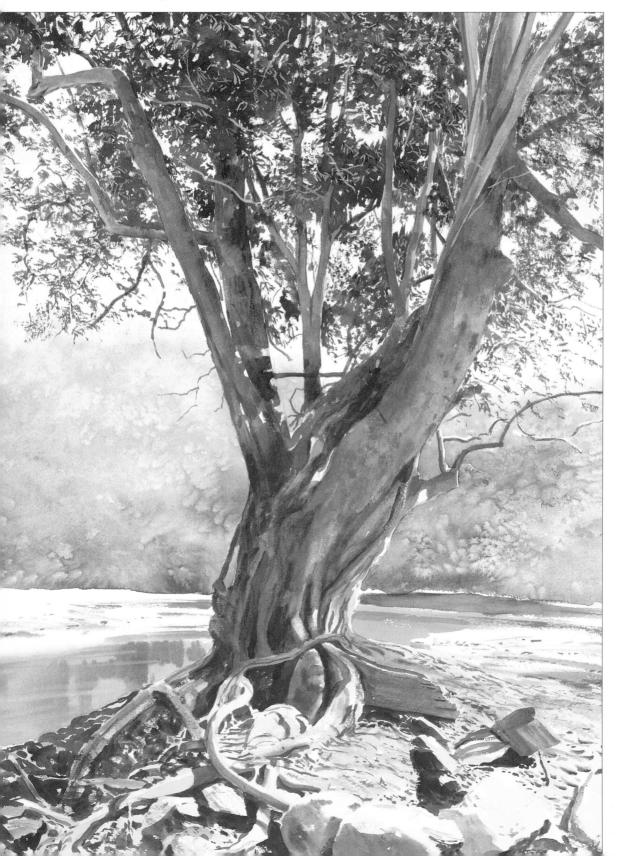

Cow Parsley

410 x 250mm (16 x 9¾in)

Foliage can be very dark in shadow, and in this scene it is used to contrast with the white heads of cow parsley. Much of the painting was worked wet into wet, giving a soft, blurred feeling in keeping with the warm, hazy late-summer day. Burnt umber, Prussian blue and viridian were painted on to a wet surface of Naples yellow and raw sienna. Detail was added when the painting was dry. Some split brush painting was used to give a bit more description to the trees and then some overpainting with Chinese white and Naples yellow was used to paint the grass and the cow parsley.

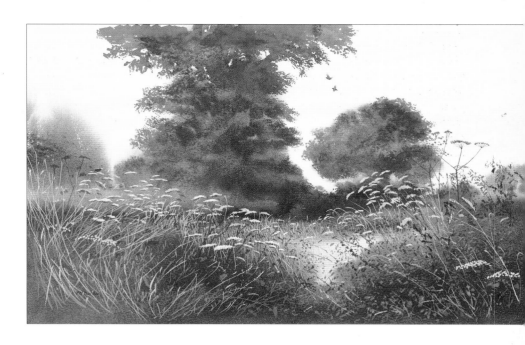

Hilltop Tree

270 x 345mm (10½ x 13½in)

As the sun went down, the tree in this painting caught the last rays of the sun. It was situated on the top of a hill in Kaikoura, New Zealand. I blended together cerulean blue and Naples yellow to give the background wash, and cerulean blue and burnt sienna to form the hillside in the foreground. Cerulean blue is a good colour for mixing pale, cool greys. Where the sun catches the foliage, I used masking fluid to retain the whiteness of the paper. The colours of the tree were made from burnt sienna, Indian red and ultramarine blue. The masking fluid was removed and the brighter orange patches of foliage were then brushed in. A little overpainting with Naples yellow was needed in the dark areas to describe the clumps of foliage, while in the foreground, burnt sienna and raw sienna were combined to paint in ridges of grass on the hillside.

63

Water

There is something very special about water. I have the feeling that I can always construct a painting if there is water involved. Its fluid nature, the colours and reflections, and its abstract quality can always lift a painting. The play of light on water has many subtle variations, and there are a number of techniques we can use to capture them on paper.

Reflections at Houghton Lock
300 x 220mm (11¾ x 8¾in)
The water in this scene has that dark, inky quality that I find irresistible in watercolour. There is little colouring here: the bank and trees form dark shadows of burnt umber and sap green against a background wash of Naples yellow with traces of red and blue. The distant tree line is a cool blue-grey – a mix of cerulean blue and Naples yellow.

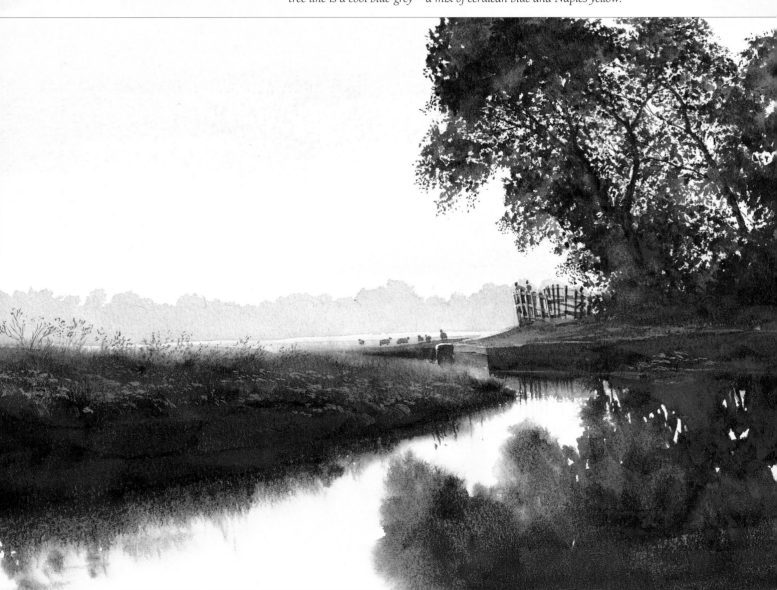

In the example on the left, I have used a little masking fluid in the distance to create sharp white lines, but the softer diagonal lines were achieved by overpainting with Chinese white mixed with a little blue.

Masking fluid (see page 25) will give a sharply defined lighting effect on water, and if necessary, a complicated pattern can be masked out in this way.

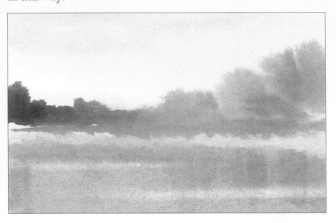

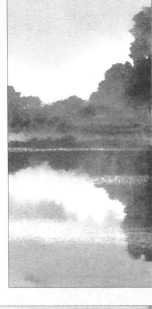

For a more speckled highlight, scratching out works well (see page 24). In this example (right), I have used a scalpel for the fine lines in the distance, and the broader lines were made using sandpaper.

For very soft results, rubbing out with an eraser is effective (see page 24). If you want to create a straight line, run the eraser along the edge of a ruler.

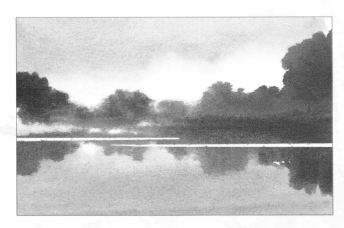

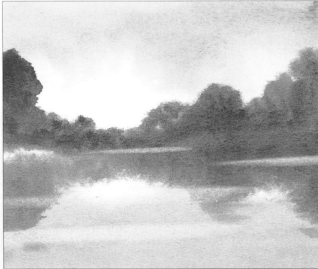

Cutting out (see page 25) can make a very sharp white line. I carefully cut two lines close together and strip out the thin slither in between them. This is particularly useful if you missed the opportunity to mask out the area earlier.

To lift out, rub a wet brush over a section of paper a few times and dab away excess paint and water with a paper tissue. Larger areas may be removed with a sponge.

Winter Reflections

This scene is ideal for demonstrating watercolour techniques, since it includes not only the water and reflections but also sky, a grassy bank, foreground foliage and plenty of winter trees that lend themselves to dry brush work.

The water creates its own particular challenges. Watercolour is the ideal medium for capturing the fluid quality of water, but in applying the second layer of wash in this painting, you need to be careful not to lift off any of the first, leaving an unpleasant, patchy result. You also need to bear in mind that the tonal range of reflections is usually a little darker than the scene reflected.

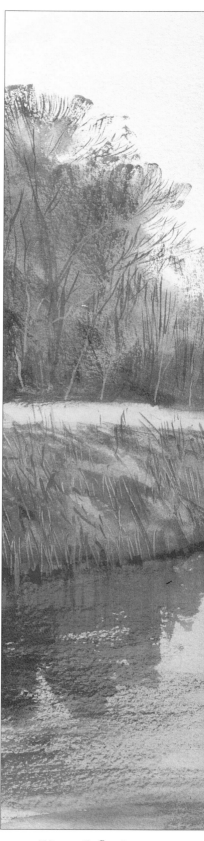

The reference photograph. This was particularly useful in this project, as there is a lot of detail in the winter trees. It was also used to check the tones of trees and their reflections.

The preliminary sketch is quite simple here. Use very light pressure when outlining the trees, otherwise you will leave unattractive lines in the wet paint.

Winter Reflections
340 x 275mm (13½ x 10¾in)
The finished painting captures the mood of the scene. When you have gained confidence, results like this can be achieved quite quickly.

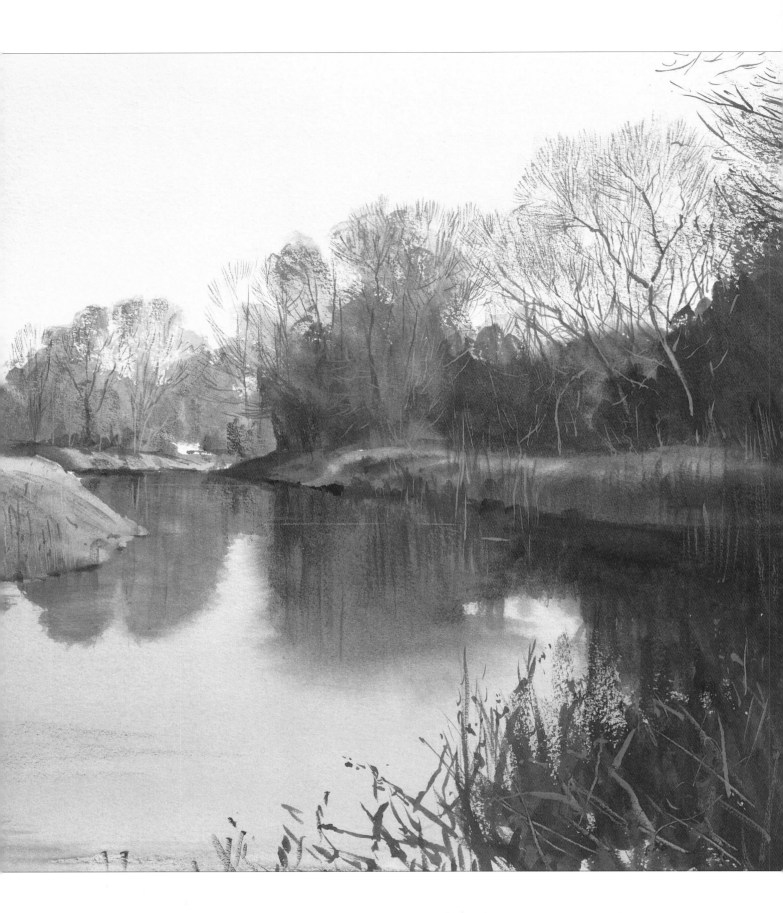

You WILL NEED

Not paper, 340 x
 275mm (13½ x 10¾in)
Naples yellow
Crimson lake
Intense blue
Burnt sienna
Raw sienna
Ultramarine
Alizarin crimson
Cadmium yellow
Scarlet lake
Indian red
Size 2, 6 and 12
 brushes
Large wash brush
Razor blade
Paper tissue

1 Wash over the whole area of sky and water with Naples yellow and crimson lake. Create a variegated wash by painting from right to left, beginning with mainly Naples yellow and adding more crimson lake to make the wash pinker on the left-hand side. Allow the wash to dry completely.

2 Use a large, soft wash brush that holds plenty of water for the second wash. Load the brush with intense blue for a strong, bright blue and wash down from the top. Wash with clear water in the middle band of the painting, and then with more blue at the bottom. Paint using only one brush stroke on any one area, or the brush will lift off the first wash from underneath. Allow the second wash to dry.

3 Soften the area of the background trees using clear water. Mix raw and burnt sienna and Naples yellow with a little ultramarine and alizarin crimson. Load a size 12 brush with the mix and remove excess water from the brush by dabbing with a paper tissue. Using the side of the brush and the dry brush technique, lightly touch it to the surface of the paper to create the distant trees.

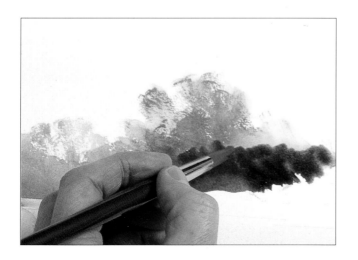

4 Soften the lower edge of the trees where they meet the grass, using clear water. Make a darker mix, adding more alizarin crimson and ultramarine to burnt sienna and raw sienna, for the right-hand side of the painting. Paint in the dark areas. Add more blue for the darker parts, and soften the edges with clear water.

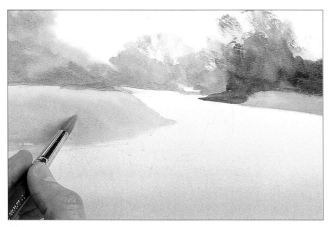

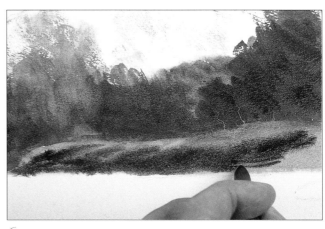

5 Mix Naples yellow and crimson lake and paint in the riverbank in the middle ground of the picture.

6 Continue painting in the twiggy areas of the trees using the dry brush technique and the dark mix. Wet the riverbank area on the right-hand side of the painting and use Indian red mixed with ultramarine to paint in the shadows.

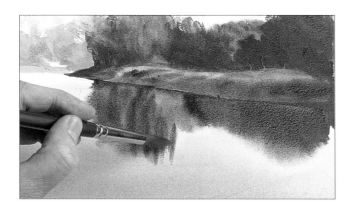

7 Wet the area of the reflection on the right-hand side of the painting. Mix Indian red and ultramarine and paint in the reflection. The paint will bleed into the wet background, creating soft edges. Add raw sienna as you go across towards the middle.

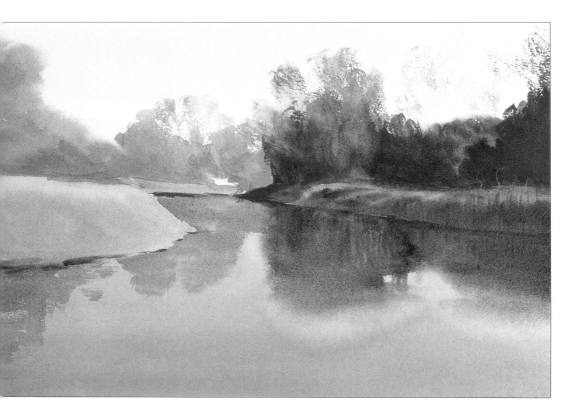

8 Use a watered down version of the same mix to paint in the reflections on the left-hand side. Use vertical strokes to create the textures and reflections on the water. Use burnt sienna for the line between the bank and the water on the left-hand side. Allow the painting to dry.

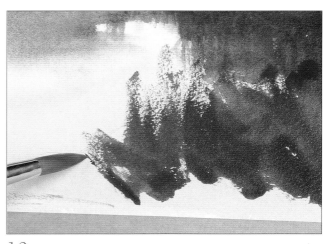

9 Mix Indian red and ultramarine and add dark reflections and shadows on the left-hand side of the water.

10 Begin to fill in the undergrowth in the foreground using a mix of Indian red, ultramarine and burnt sienna and a size 12 brush.

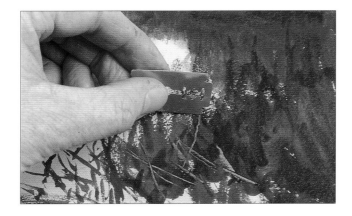

11 Using raw sienna, paint in the grass stems in the foreground undergrowth. Then take a razor blade and, while the paint is still wet, scratch out the texture in this area.

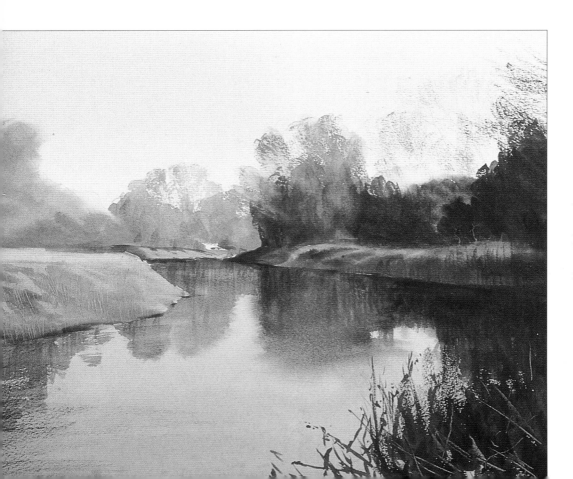

12 It is now time to begin adding finer details. Use burnt sienna and ultramarine to add vertical lines in the water. Mix ultramarine, raw sienna and crimson lake and add shadows and grass to the riverbank. Use a mix of scarlet lake and raw sienna for the water's edge. Paint a warm line along the top of the bank using cadmium yellow mixed with scarlet lake. Finally, scratch out the grasses on the left-hand bank using a razor blade or craft knife.

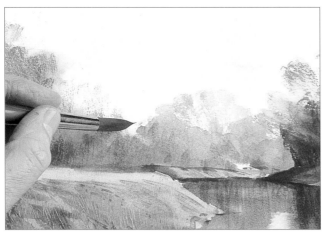

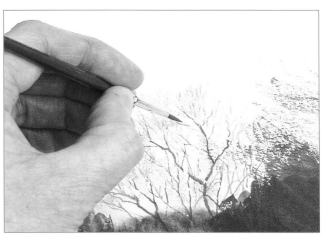

13 Add detail to the bank and the distant trees above it on the left-hand side of the painting, using burnt sienna.

14 Paint in the fine detail of the branches and twigs on the right-hand side using raw sienna, Indian red, burnt sienna and ultramarine blue. Use a size 6 brush for the branches and a size 2 for the very fine twigs.

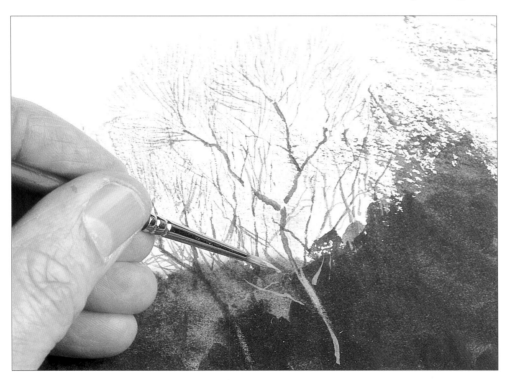

15 Continue with the twigwork. Overpaint the highlights on the tree trunks using Naples yellow mixed with scarlet lake. Using the same mix, overpaint the foreground foliage and the surface ripples on the water.

TIP

At this stage it is worth standing back and looking at the painting as a whole to see what needs to be added. With this painting I decided to add warmth to the reflections in the middle using raw sienna and scarlet lake on a size 12 brush.

The finished painting, also shown on pages 66–67

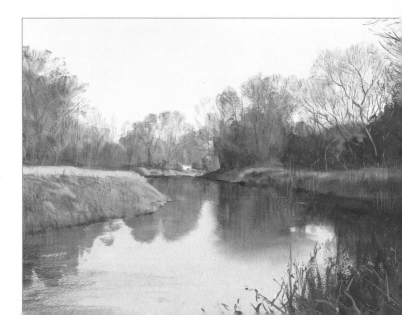

Ghost Gums

280 x 345mm (11 x 13½in)

A common sight at the water's edge in Central Australia are the ghost gum trees. Their white trunks reflect in the blue waters, making an excellent subject for watercolour. Masking fluid is useful here for painting out some of the branches that would otherwise be difficult to paint around. The landscape was brushed in briskly with a mix of Naples yellow and a touch of scarlet lake, leaving small areas in the background where the blue of the sky is visible. Detail and shape were then added with burnt sienna, scarlet lake and Indian red. Some of the shadows are quite vivid in colour: the dark shadow to the left was mixed with dioxazine violet and Indian red.

The base colour for the foliage is the same colour mix as the landscape. This was then worked over using the dry brush technique with a mix of raw sienna and ultramarine blue to give the patina of leaves.

The reflected scene was painted a little deeper in tone, and some edges were softened near the bank to give a convincing watery feel. A few brushstrokes were added to the surface of the water using a little Chinese white and Naples yellow, where there is movement in the water or where the light catches it.

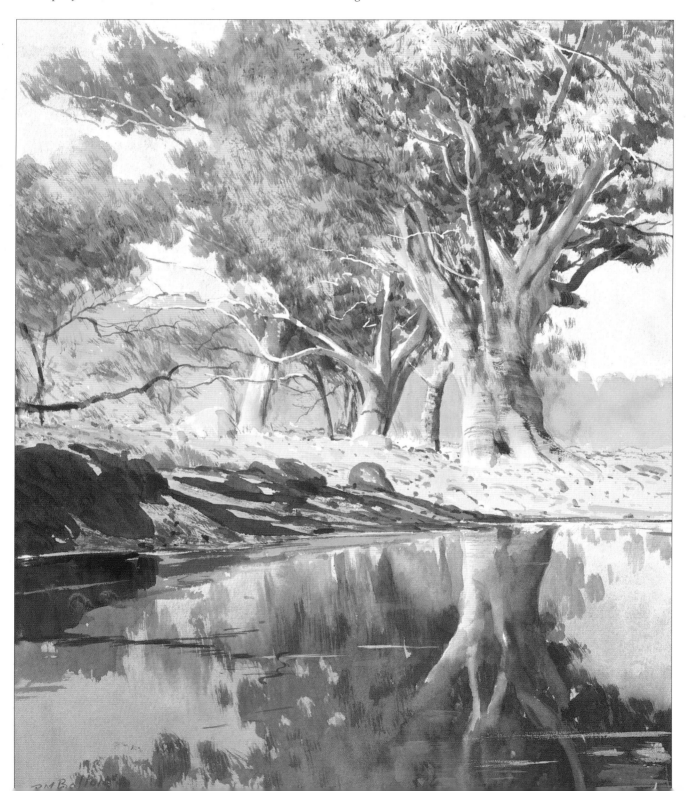

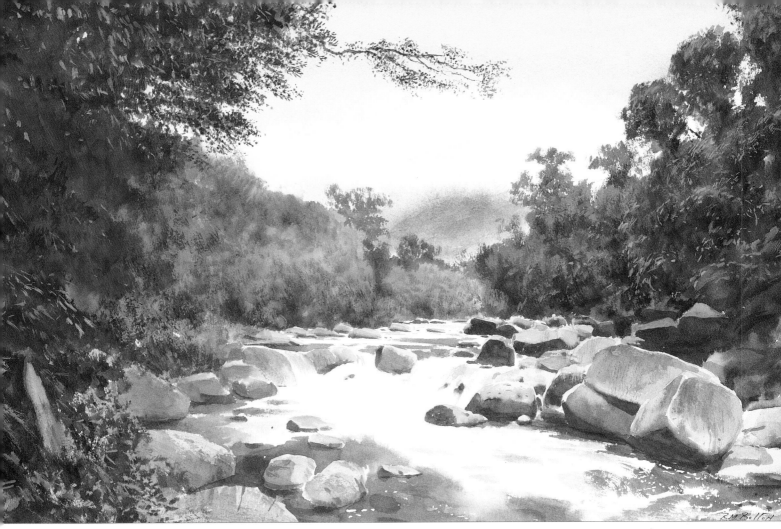

Mossman Gorge

530 x 350mm (21 x 13¾in)
The foliage here is quite a drab green, and would make rather a sombre scene if it were not for the foaming water cascading round the rocks. The white of the water contrasts well with the dark foliage. I used some masking fluid in some of the areas that would be difficult to brush around.

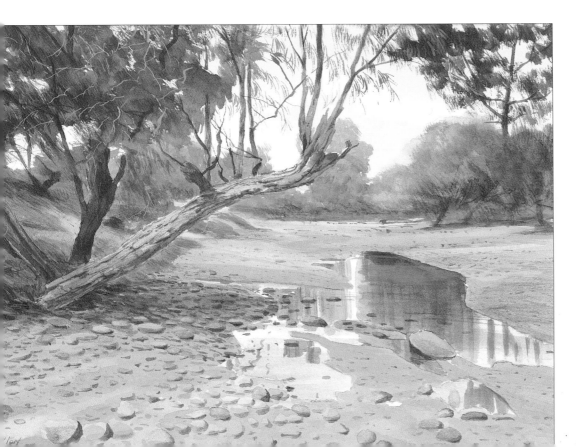

Riverbed Reflections

350 x 260mm (13¾ x 10¼)
It is surprising how simple things can make an attractive painting. Here I have concentrated on a patch of water, a few stones and a stunted tree. It is the puddle of water reflecting the blue sky that brings the painting to life. The painting has been kept simple, with only a suggestion of detail here and there. The closest work was picking out the ragged quality of the bark of the small tree.

73

Hills and mountains

It is important to remember, when tackling this area of landscape painting, that hills and mountains always have a discernible structure. If you look closely, you will see that there is a pattern to the way rock breaks up and to the way valleys are formed. The nearest mountains I have to paint are the Cambrians in Wales, said to be some of the oldest in the world. Here, the mountains are worn down to rounded humps and contrast dramatically with the towering, jagged peaks in Tibet that I have also painted.

When painting hills and mountains, it is easy to get caught up in detail and lose the sense of scale and distance. You need continually to stand back and assess your progress. It is easy to get the skyline wrong where it meets the mountains. There may hardly be a line at all if there is any haze, so avoid painting the sky down to the mountains and the mountains up to the sky. This is an easy mistake to make, but will give you an unnatural-looking hard line dividing the two, as shown below.

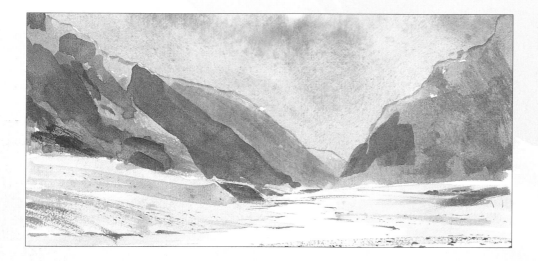

In this example, I have painted the background sky down to the outline of the mountains, and then met this line when brushing in the mountains. You can see why this does not work: a line has developed between the two.

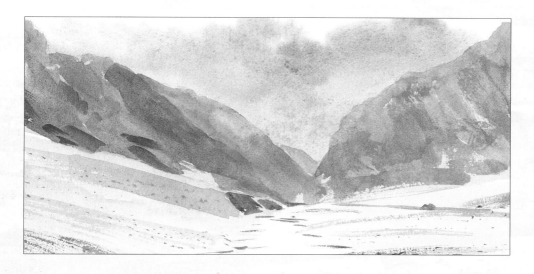

Here I have painted the sky right down to the base of the mountains, so that when I brush in the mountains, I do not create an unnatural-looking line.

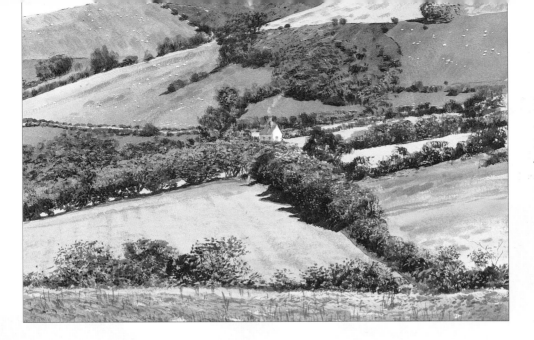

Hillside, Mid-Wales

310 x 220mm (12½ x 8½in)
The small white cottage offers a good focal point in the picture, and the patchwork of fields makes an interesting pattern. The ragged quality of the hedges has been created using a size 6 brush and the dry brush technique, carefully avoiding overloading the brush to get the correct textural qualities.

Yumbulangang Monastery

730 x 530mm (28¾ x 20¾in)
Situated on a rocky peak, the Tibetan monastery in the painting below presents a dramatic outline against the sky. The background was painted with speed and vigour to keep the painting lively. The mountains in the foreground were also painted in broadly with a mix of ultramarine blue and Indian red, and then the rough texture of the rocks was scrubbed in using the dry brush technique, with a lot more Indian red in the paint mix.

The figures add a welcome touch of colour. Figures are also useful indicators to scale in a landscape. Since the girl is wearing a white shirt, I had to use masking fluid at the outset to prevent losing the white of the paper during painting. Masking fluid was also used for the hands and faces. The darker colours of the skirts and headgear were overpainted.

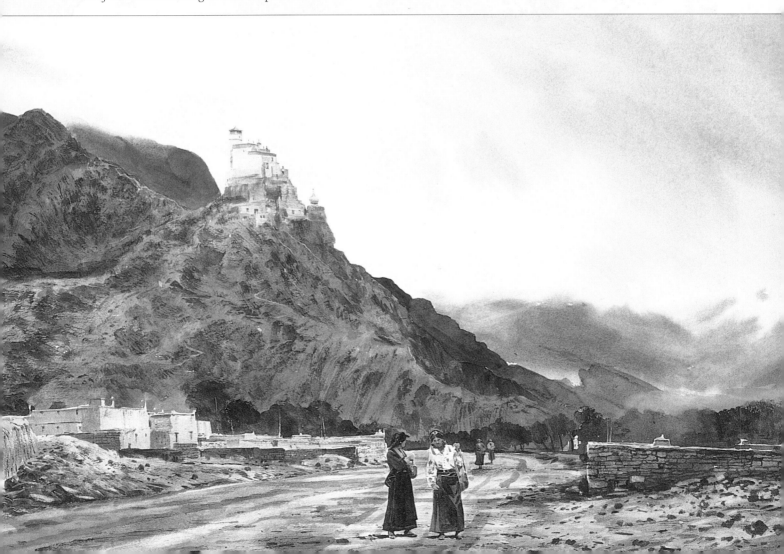

Mountain Stream

This is a painting of a valley in the Himalayas. However, the scene is quite modest and could represent a mountain scene in many parts of the world. As always, water adds something to the scene: in this case a babbling brook adds movement in the foreground.

The painting combines many different techniques. Masking fluid is used to mask out the white parts of the water and some of the highlights. The dry brush technique has many functions here: it creates a speckled effect on the green hillside, the texture of the rocky outcrops and the appearance of movement in the foreground water.

When painting the foreground, you need to work with the usual speed and spontaneity of the watercolour technique, creating the effect of a rocky area but without getting lost in the detail.

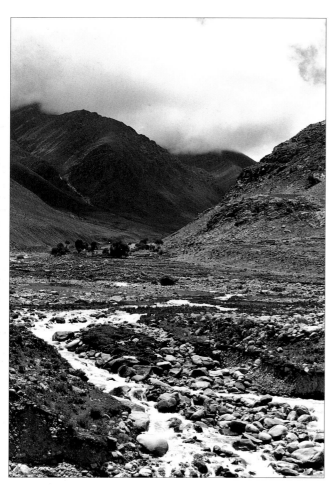

The preliminary sketch. Take a bit more time over drawing the rocks and stones in the foreground as it will be a great help as you work around them with the brush.

The reference photograph. You can see that the rocky area in the foreground has been reproduced fairly faithfully in the painting. Water brings a picture to life: this cascade of foaming water creates a lively pattern against the darker tones of the hillside.

Mountain Stream
*260 x 335mm (10¼ x 13¼in)
The finished painting*

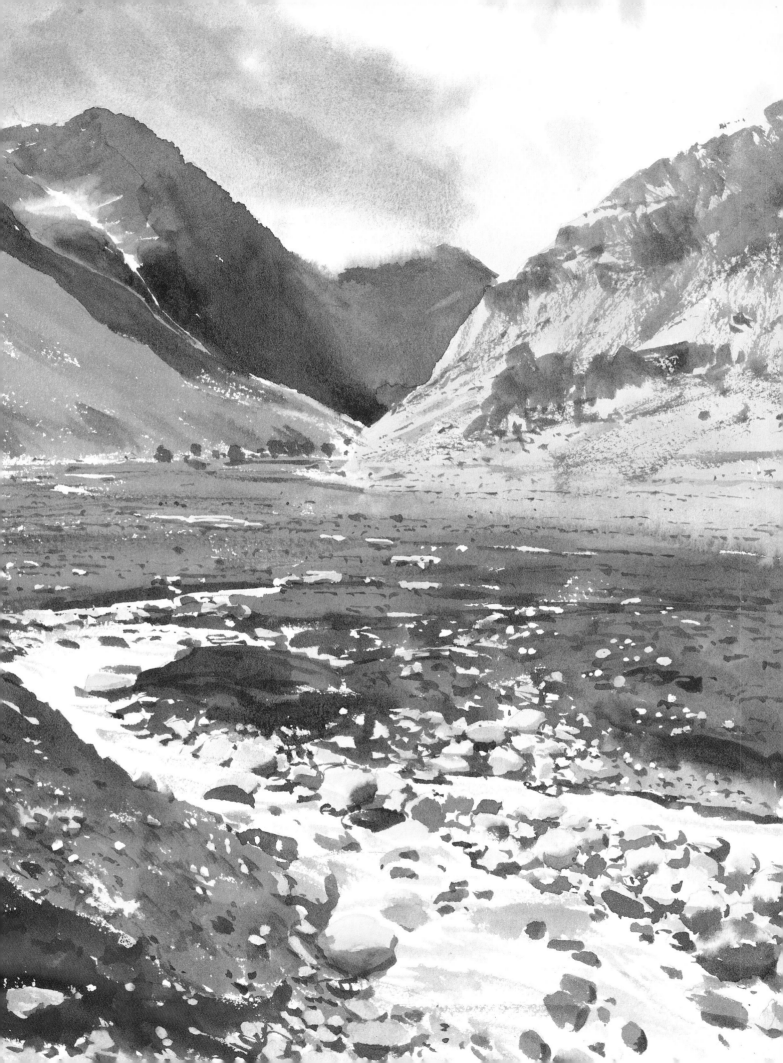

1 Mask out the white areas of the river and the highlights on the stones using masking fluid and a fine old brush.

TIP

A large brush will come to a fine point as well as a small one. Use two size 12 brushes for this project, one with clear water for softening edges – otherwise you will waste a lot of paint continually rinsing out your brush.

2 Wet the sky area of the painting, and some of the distant mountains, with clear water. Pick out the blue in the sky and the distant mountains using cerulean blue and a size 12 brush, painting wet in wet and allowing the blue to run into the wet paper. Paint the clouds wet in wet using a mix of ultramarine blue with a little burnt sienna. Paint a little vermillion into the white areas of the sky. Allow to dry.

3 Paint the dark mountains in the background using Prussian blue, cadmium yellow and burnt sienna. Soften the edge of the mountains where it meets the low cloud by running a wet brush over it.

4 Create the jagged edge of the mountain by painting with the tip of your brush.

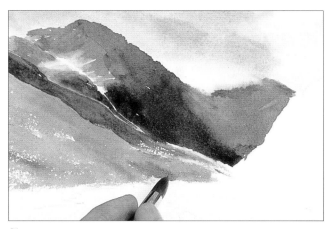

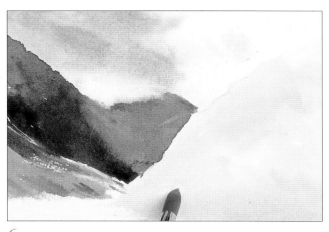

5 Fill in more of the dark mountain area using the same mix of Prussian blue, cadmium yellow and burnt sienna. Leave a white line for the stream. Using a lighter mix, fill in the more sunlit slopes, joining them to the darker areas to create soft edges. Use the dry brush technique to create a speckled white effect.

6 Wash in the warmer mountainside using a mix of raw sienna and burnt sienna.

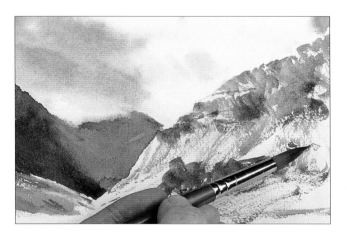

7 Use the dry brush technique and a mix of burnt sienna and ultramarine to paint the rocky outcrops on the warmer mountainside. The brush should be on its side, scuffing across the surface of the paper to achieve the desired rocky texture. Paint dots of shadow under the rocks with the same colour mix.

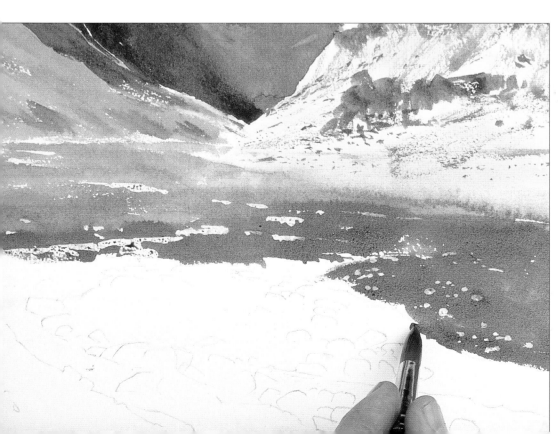

8 Paint in the greenish area towards the foreground using a mix of Prussian blue and a little raw sienna and burnt sienna. The brush should be fairly dry, so that the paint creates speckles on the surface of the Not paper. Soften the edges where the green meets the rock colour using clear water. As you paint nearer the foreground, use a stronger colour mix . Combined with the paler shades in the background, this creates the illusion of distance known as aerial perspective. The masked out areas will begin to show through at this stage.

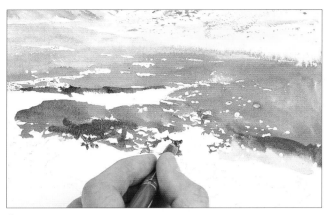

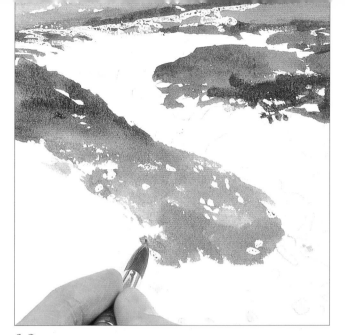

9 Start describing the rocks in the stream using the very tip of the brush and the same dark green mix as before. Do not get lost in the detail: create broad shapes and work quickly to maintain the spontaneity of the watercolour painting process.

10 Use the same mix to paint in the distant trees. Add a little emerald green and paint the grassy bank in the foreground.

11 Wet the dark area under the grassy bank, and its reflection in the water, and paint it with a mix of Indian red and Prussian blue. Soften the edges with clear water.

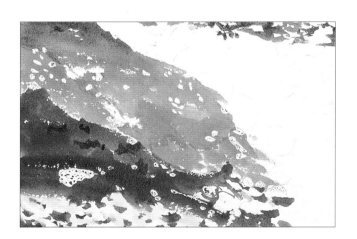

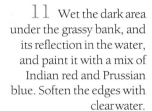

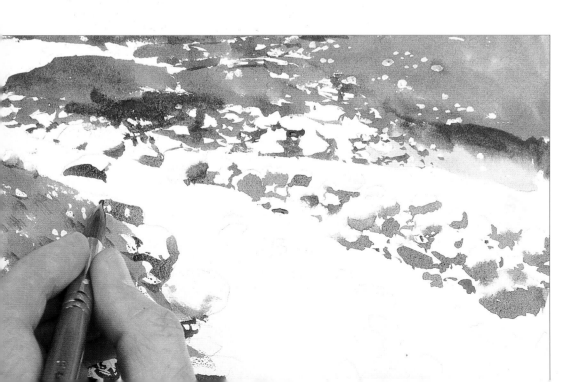

12 Use a mix of ultramarine blue and burnt sienna and the dry brush technique to work the rocks in the foreground. Softening the edges of rocks with water helps to describe their roundness.

13 Rub off the masking fluid using an eraser. Paint in the highlights on the foreground rocks using a little ultramarine.

14 Continue adding form to the rocks in the foreground and middle distance, as well as other details, using ultramarine.

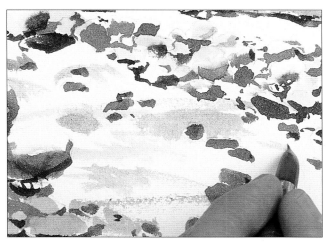

15 Mix cerulean blue, burnt sienna and raw sienna and use the dry brush technique to create the effect of movement in the water.

After standing back from this painting, I added warm highlights to some of the foreground and middle ground rocks using a mix of Naples yellow and vermillion.

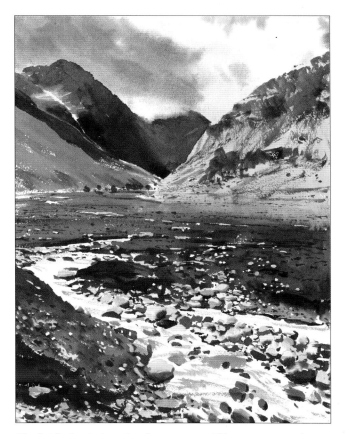

The finished painting, also shown on page 77

Following pages:
Arthur's Pass
660 x 410mm (26 x 16¼in)
Snow is thawing on the hillsides of this mountain pass in New Zealand. The cool, clear sky reflects on the mountains and contrasts with the darker shades of the foreground.
The sense of distance is all-important in a view like this, and you can see that the snow-clad mountains are more strongly defined as they get closer to us. The same applies on the left, where the colours are stronger on the hillside close to us, while the slope behind has a blue, milky quality. Adding a little Chinese white to the background colours is a good way of achieving this effect.
This painting is a good example of avoiding hard lines between mountaintops and sky, as described on page 74: the snow-clad mountains merge with the sky, and are defined by their shadows only.

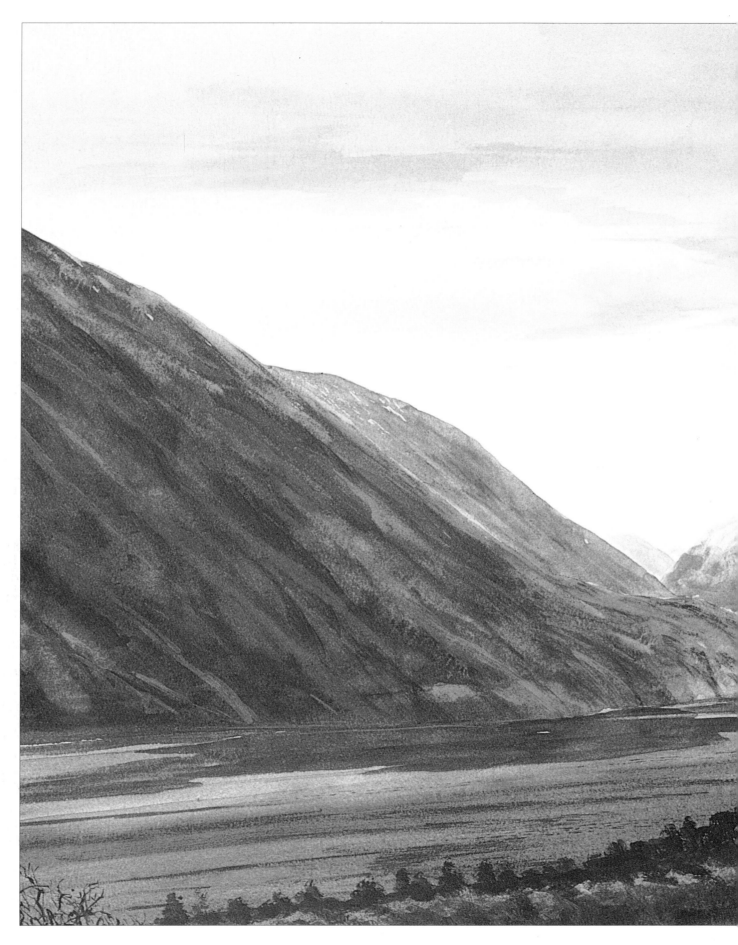

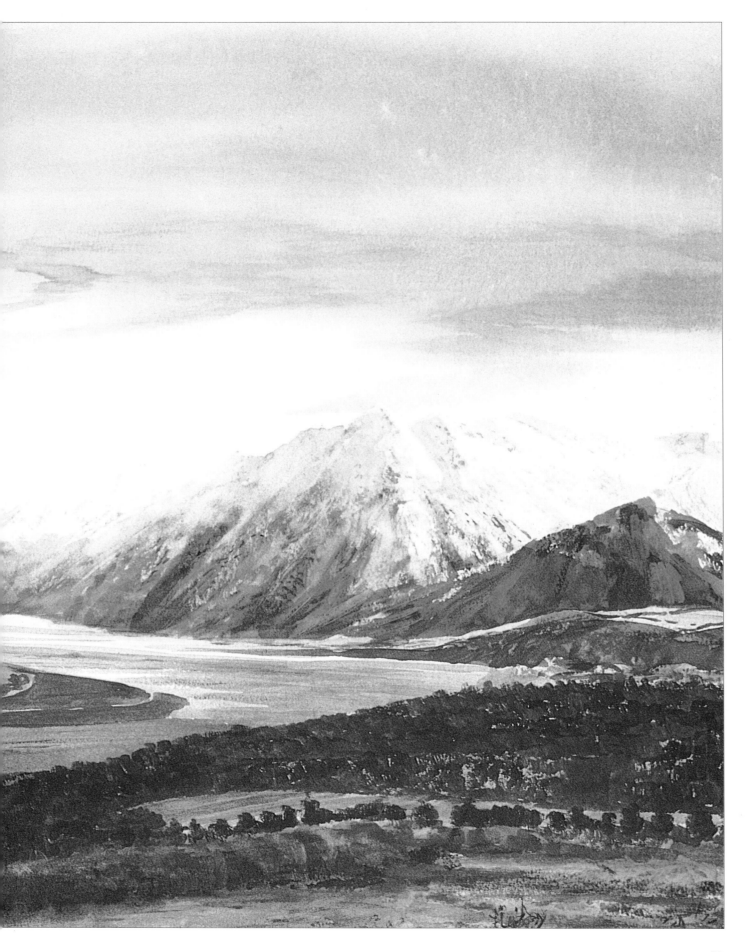

Snow and ice

Snow can be very dramatic in watercolour as the white of the paper shines through, giving the scene luminosity.

The thistles in the painting below make an interesting subject on a bitterly cold day, with their shadows cast by a watery sun.

There is little colour in this painting: it is mostly ultramarine blue and burnt umber, though there are touches of alizarin crimson on the thistles and a little added to the blue of the snow. Masking fluid was useful here to mask out track marks and highlights in the mud.

Church spires often feature in an English scene, and are a useful aid in composition. They help to indicate scale and distance, though care needs to be taken when painting to ensure that a spire is straight and vertical – it is very difficult to correct something that is set against the skyline.

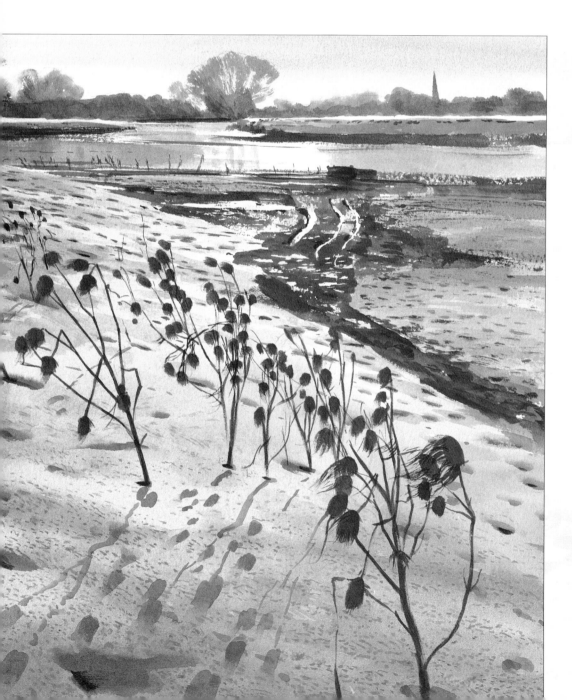

Thistles
265 x 345mm (10½ x 13½in)

Snow Thaw
270 x 390mm (10¾ x 15½in)

In a painting like the one shown above, patches of snow are best masked out from the start. The great advantage of masking fluid is that it can be painted on in quite broad areas, but it can also be used for quite detailed work. In the field in this painting, small spots have been masked out to create the distant specks of snow.

The branches and twigs are a good subject to paint with the rigger brush. The long, thin hairs are ideal for sweeping in the many long, fine lines. In the same manner, some lighter blades of grass and twigs have been overpainted with a mix of Naples yellow gouache mixed with a little burnt sienna.

Tracks in the Snow

Simple scenes can take on great charm after a fall of snow. Even these tractor tracks in the mud look picturesque filled up with snow.

Snowy landscapes combined with brightness in a winter sky can create subtle and unusual lighting effects. These are captured in this painting by using four washes, one on top of the other.

The preliminary sketch. Minimal drawing is required here, but take care that the church spire is correct, and perfectly vertical. It is the first thing that will catch the attention of the viewer.

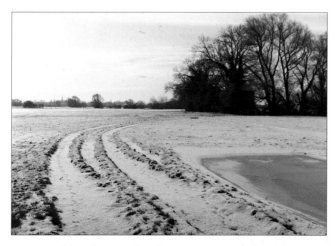

I composed this photograph with a painting in mind, with the tyre tracks leading the eye into the scene.

Tracks in the Snow
350 x 255mm (13¾ x 10in)
The finished painting

86

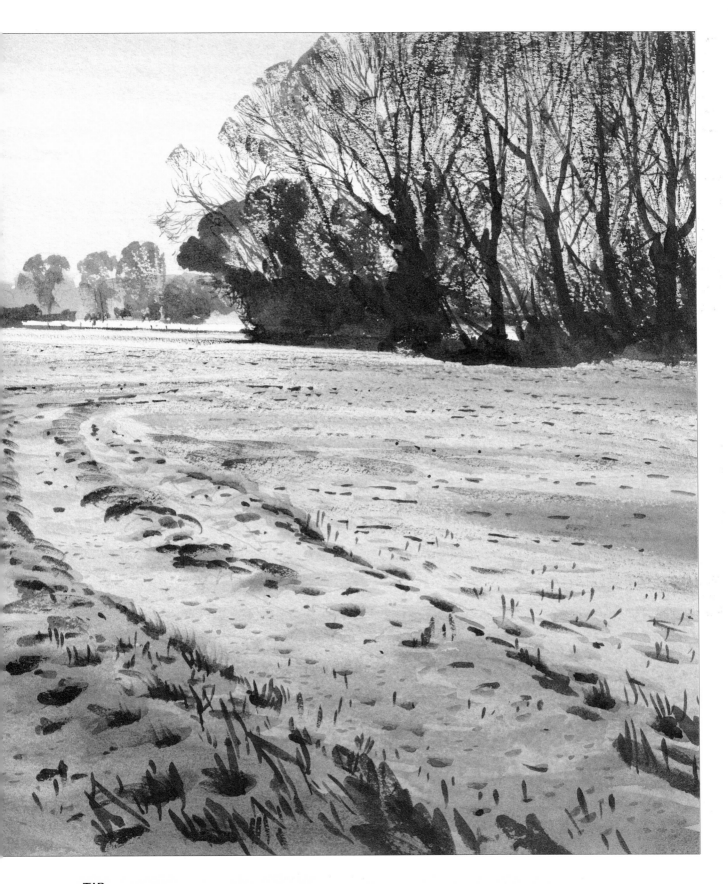

TIP

To make snow convincing, add animal tracks and footprints, dab the shadows of the footprints in the snow and then soften the upper edge with clear water.

YOU WILL NEED

Not paper, 350 x
 255mm (13¾ x 10in)
Naples yellow
Cadmium yellow
Scarlet lake
Ultramarine
Alizarin crimson
Cerulean blue
Chinese white
Burnt sienna
Vermillion
Sap green
Indian red
Size 2, 6 and 12
 brushes
Paper tissue

1 Apply a background wash for the sky, using a mix of Naples yellow, cadmium yellow and a touch of scarlet lake. Use a size 12 round brush and wash only down to the horizon line.

2 Start the second wash with the same mix at the top of the painting. Add some more scarlet lake, making the colour stronger as you come towards the foreground. Allow to dry.

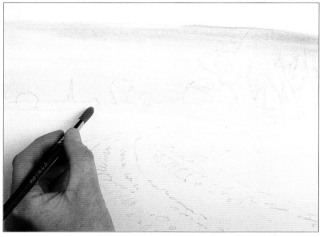

3 Mix the sky wash from ultramarine with a little alizarin crimson. Wash down from the top using a size 12 round brush, leaving spaces for lighter areas of the sky. Soften the edges using clear water. Allow to dry.

4 Mix a wash for the field using ultramarine with a little alizarin crimson. Leave a strip of light in the background and wash down. Nearer the bottom of the painting, the colour should become stronger.

TIP

Take excess paint off the bottom edge of the painting by wiping with a paper tissue, otherwise there is a danger that the wet paint will bleed back into the dried wash and create an unwanted hard edge.

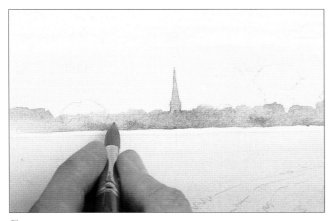

5 Soften the horizon line with a wet brush. Paint in the chruch spire and distant trees, using a mix of cerulean blue with a little alizarin crimson. Add a little opaque Chinese white to create the effect of distance.

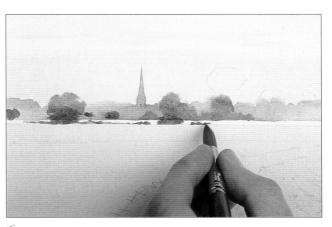

6 Paint the trees and hedgerows just in front of the horizon line in burnt sienna mixed with ultramarine and a little alizarin crimson.

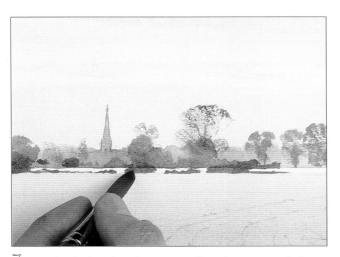

7 Use the dry brush technique, scuffing the paper with the side of the brush, to create the speckled effect of the winter trees. Add fence posts and other details.

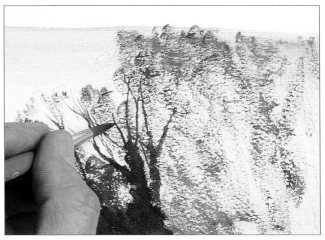

8 Make a strong mix of burnt sienna, ultramarine and alizarin crimson. Take excess water off the size 12 brush with a paper tissue. Build up the large tree with the side of the brush to create the ragged edges. Pick out the branches with a size 6 brush.

9 Pick out the finer details of the twigwork using a size 2 brush and the same strong mix, and working quickly to avoid becoming bogged down in the detail.

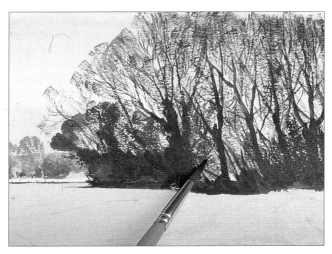

10 Block in the trunks using the dark mix and a size 12 round. Use a size 6 brush to complete the detail.

11 Drag a dry size 6 brush with a little of the same brown over the snow area to create texture. Take a size 2 brush and using the same colour, touch in the tufts of grass poking through the snow.

12 Paint in the shadows on the snow with ultramarine, and soften the edges using a wet size 12 brush.

13 Fill in the larger shadowed areas using ultramarine.

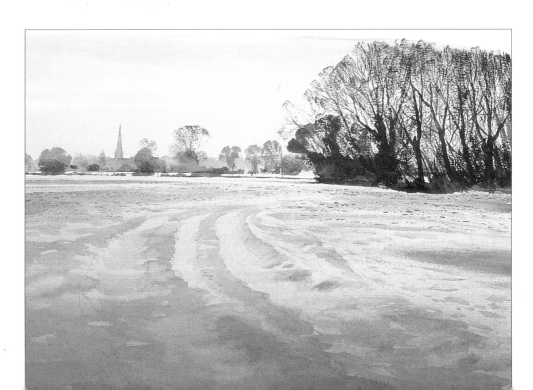

14 Paint in tyre tracks and all the remaining shadows on the snow, using ultramarine. Vary the depth of colour to suggest the dappled effect of light and shadow on the snow. Allow to dry.

15 Paint in the footprints in the snow using a size 2 brush with ultramarine mixed with vermillion to grey it.

16 Soften the edges of the footprints using a wet size 6 brush.

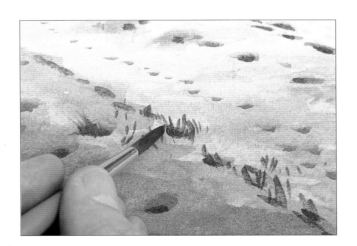

17 Mix sap green, burnt sienna and ultramarine and use a size 6 brush to paint in the areas of earth showing through the holes in the snow. Soften the top edges with a wet brush, to make it look as though tufts of wintry grass are growing through the holes. In the foreground, strengthen and warm the colour of the grass by using Indian red mixed with sap green.

Having surveyed the painting as a whole at this stage, I went on to add further tufts of grass over the blue shadowed areas, and details of tracks in the snow.

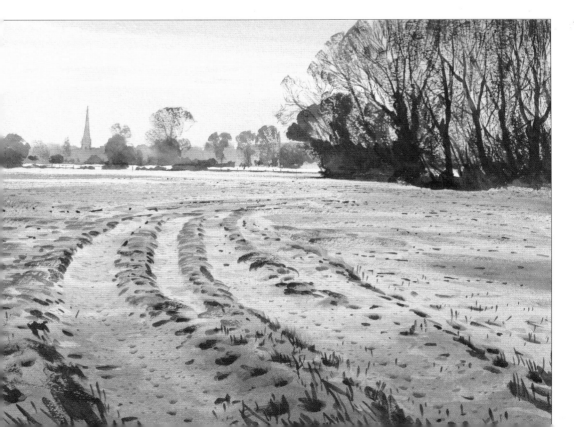

The finished painting, also shown on pages 86–87

Problem solving

One factor that puts people off watercolour more than any other is the idea that a painting is permanent and that errors will remain there indelibly for ever. This is not quite true: we cannot make changes as easily as a painter in oils, but there are ways in which paintings can be rescued. As an example, I have taken a painting that has not worked out of my drawer.

The scene below showing the pollarded willow has become overworked and dull. This is a common problem that has ruined many a watercolour painting. Rather than discard this one, I have decided to try and rescue it.

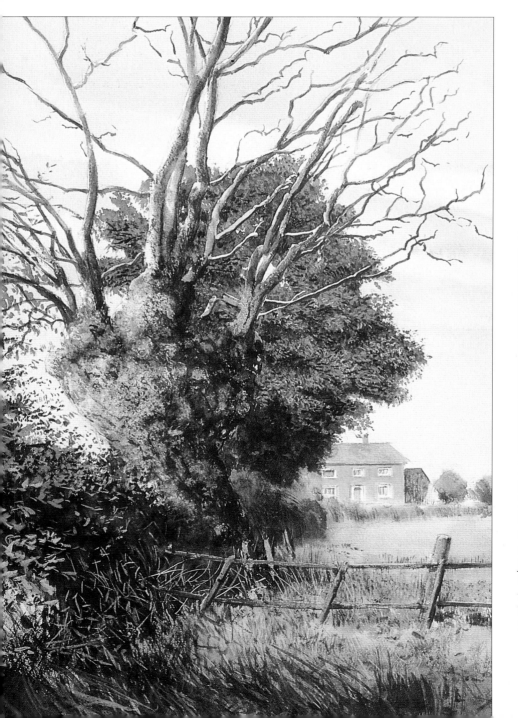

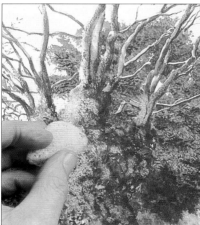

1 The first stage is to remove paint from where it has become overworked. This is done by sponging away paint from the tree trunk and surrounding undergrowth. Take care at this stage not to flood the painting with water: use just enough to wet the sponge. After a few gentle wipes, much of the colour will be removed, leaving a pale grey background – in this case a good colour for the tree trunk.

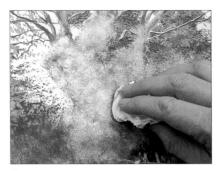

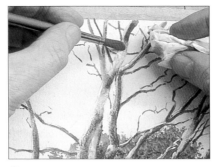

2 You can lift out some of the paint from the sponged area by dabbing carefully with a paper tissue.

3 Lift out any unwanted texture from the smaller areas such as the branches using a fine brush dipped in clear water. An oil painter's bristle brush is particularly good because it can scrub away the paint without doing any damage to the paper.

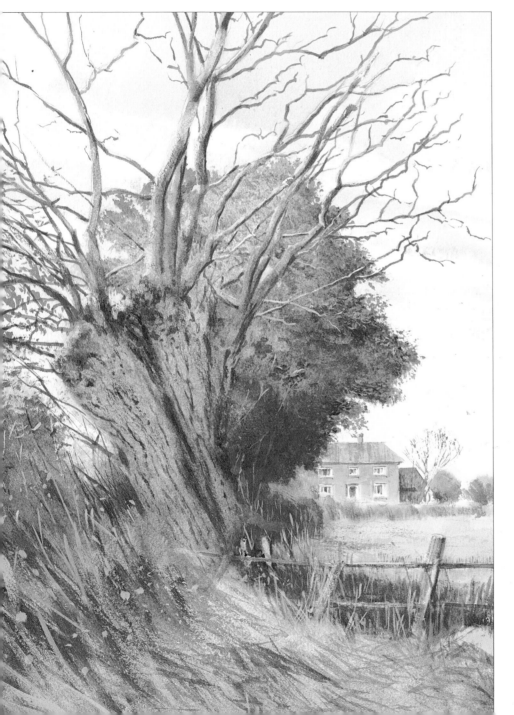

The finished painting. Once the overworked areas had been lifted out, I was able to have another go at painting them. The foreground is still in deep shadow but the detail of the willow is more effective this time.

Corrections in the sky are much harder to achieve. Small areas sponged away are likely to stand out too much, so it is often best to wet the entire sky area and treat it as a whole. Use as large a brush or sponge as possible, to avoid streaks or marks.

Sometimes dark spots can be made in the sky where a tiny piece of rubber or dust attracts the surrounding paint. This is best avoided in the first place by sweeping the paper clean before starting a wash. When it does happen, the speck of dirt can be carefully lifted away on the tip of a damp fine brush. On no account use a brush fully charged with water: it will disperse on to the painted surface and leave an ugly patch on your painting. When dry, spots can also be removed by gently touching with a damp brush to remove colour, then dabbing with a paper tissue. A gentle touch is needed to avoid ending up with a white patch.

It might be tempting to try overpainting to rescue a painting by covering up the problem. This is unlikely to work, however. Watercolour is a transparent medium, and overpainting can spoil this quality, so is best reserved for minor additions of detail or texture. A popular way to disguise spots that disfigure the sky is to turn them into birds in flight: some of our greatest painters used this technique, so you would be in good company!

Hard edges can form when a wash dries, and this can be a serious problem. The greatest risk comes when you put a lot of water on the paper, hoping for a dramatic effect – usually in the sky. There is little you can do if hard edges form here: even if you immerse the painting in water and scrub, the marks will still remain. The only solution is to avoid them in the first place. To do this, tilt the painting and drain off excess water, and then use a paper towel to mop up round the edges. Place the board on a level surface and allow it to dry slowly. I like to add a little Naples yellow to my washes, as this seems to help prevent hard edges forming. Different papers have different characteristics, and you may be lucky and find that hard edges do not form on your preferred type of paper.

Washes can be built up in layers, one on top of the other. The danger is that the second wash may dissolve the first and you will see the evidence of this as stripes appear when you complete the second step. If the second

Hard edges like this are quite dramatic but can be a disaster in a sky wash.

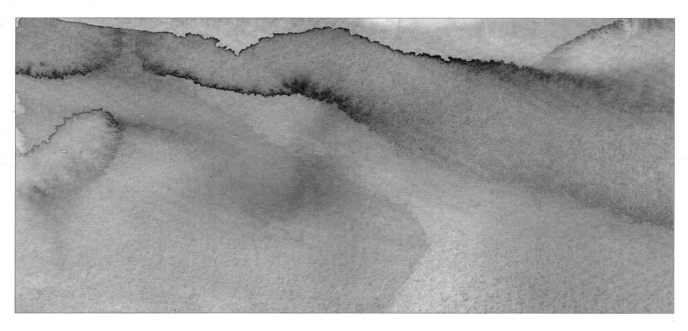

wash is added while a section of the first wash is still damp, a whole section will be lifted away, leaving an ugly, irreparable mark.

Always make sure that the painting is completely dry before progressing. When you start the second wash, make sure you are using the biggest brush possible: the quicker and more efficiently you can complete the task, the better. As you apply the paint, ensure that the brush passes over each section once only. If you try to go back and make an amendment, this will lead to the lifting of the first wash. In small paintings, these problems are not so great, but in large paintings the risks increase greatly.

If for some reason the wash does emerge with stripes, the best thing to do is to take a clean sponge and clean as much of the paint away as possible, rubbing the paper gently so as not to damage it. This should remove the stripes and enable you to have another go.

The River at Funhuan (China)

415 x 320 (16¼ x 12½in)

Given the difficulty of repairing mistakes in watercolour, it is important to get details like brickwork right the first time, as in this example. It helps to draw some fine construction lines first to keep the rows of bricks level. I also count the rows in a section to get the scale right. If you don't do this, it is very difficult to correct mistakes later. As I paint, I vary the colours as I go along, to bring out the age and irregularities of the structure.

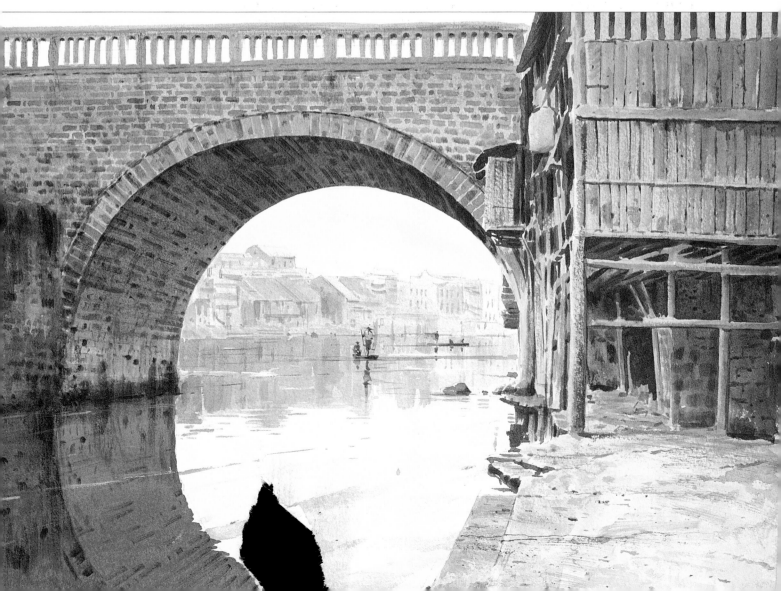

Index

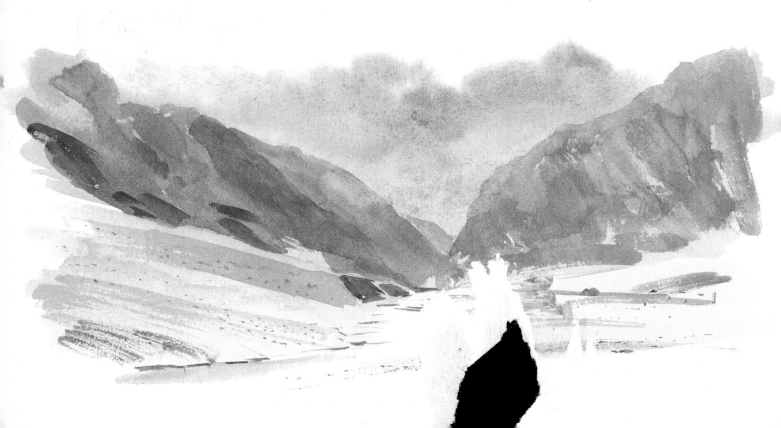